Contents

Acknowledgements

I am a potter first, not a writer, so I thank Kathryn MacDonald for patiently reading my manuscript and making valuable suggestions and corrections. Thanks also to my friend David Schlesinger for doing the same.

I thank David Snair (California, USA) whose 1975 article in *Ceramics Monthly* inspired me to try crystalline glazing. Through letters, Dave and I became friends and I appreciated his suggestions and encouragement.

Derek Clarkson (Lancashire, England) and Red Shirley (Arkansas, USA) became interested in my project and freely offered information and material.

Peter Rose and Albert Gallichan allowed me to reproduce work from their collection.

For technical expertise, I thank Drs Michael Sayer and Heather Jamieson (Queen's University, Ontario, Canada) and Dr David Creber (Alcan International, Ontario, Canada).

Before starting this project, I sent questionnaires to potters all over the world. The response was overwhelming. I received crystalline glaze recipes, photographs, finished pots, and one potter even sent glazes through the mail. I soon came to realise there was a need to organise all this information and make it available. This book could not have been written without the contributions of these potters. I dedicate this book to them, with gratitude. I also gratefully acknowledge the Ontario Arts Council for their generous support.

Finally, I offer a special thank you to Tim De Rose, my husband and fellow potter.

Some of the richest colours of flowers... are produced by a crystalline or sugary frost-work upon them. If you can fancy very powdery and crystalline snow mixed with the softest cream, and then dashed with carmine, it may give you some idea of the look of it.

John Ruskin

First published in Great Britain 1997
A & C Black (Publishers) Limited
35 Bedford Row
London WC1R 4JH

ISBN 0-7136-4615-2

Published simultaneously in the USA by
University of Pennsylvania Press
4200 Pine Street
Philadelphia, PA 19104-4011

ISBN 0-8122-1648-2

Copyright © Diane Creber 1997

CIP catalogue records for this book are available from the British Library and the U.S. Library of Congress.

Cover illustrations
Front Vase by Diane Creber, cobalt crystalline glaze. Photograph by Ernie Sparks.

Back Detail of a powder box by Joyce Greenhill, 6in. x 4in.

Frontispiece Vase by Diane Creber, 11in. high. Crystalline glaze with cobalt colourant. Photograph by Ernie Sparks

Designed and typeset by Alan Hamp

Printed in Spain
by G. Z. Printek, S.A.L.

CRYSTALLINE GLAZES

Diane Creber

**WILTON
POTTERY**

Creber

A & C Black · London

University of Pennsylvania Press · Philadelphia

Introduction

There are as many different types of pottery glazes as there are individuals who work at the craft. Some glazes are solely decorative, others give a smooth surface for functional use, and some glazes are necessary to seal the clay so it will contain a liquid. There are glossy and matt glazes, raku and salt glazes – and then there are crystalline glazes!

Crystalline glazes instantly capture the eye. They can dazzle and excite. They are seductive. Turning a piece to the light, the intricate crystals appear to float within the glaze. Images of frost, flowers or thistles blowing in the wind excite the imagination. Why do these glazes turn heads? Is this attention justified? Simply because it is a crystalline glaze in no way guarantees that the whole piece will be aesthetically pleasing. Too often, the glaze overshadows an unsuitable or poorly made form.

Using crystalline glazes is much more than a technical process involving recipes and firing schedules. It is understanding what crystals are, how they grow, the ingredients that go into a crystalline glaze, and how each ingredient reacts in the melt. To really know the glaze and when to use it is a skill that requires research, time and a sensitivity to artistic expression. Perhaps it is in the working with porcelain and the use of crystalline glazes where technology and art are most compatible.

Bottle by Diane Creber, Canada.

Most crystalline glazes are used on porcelain. It feels smooth and cool, and it can impart a brilliance to the glaze that stoneware cannot. Therefore, it seems natural that porcelain and crystalline glazes go together.

I remember the first time I saw a crystalline glaze. It was at a craft show, and the potter had a whole display of crystalline-glazed pots. Although I had been a potter for several years, working exclusively in porcelain, I had never seen anything so intriguing. I was fascinated

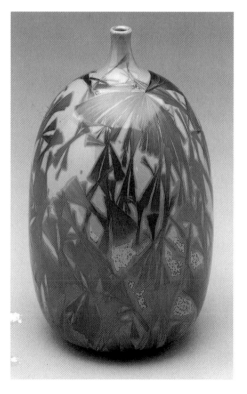

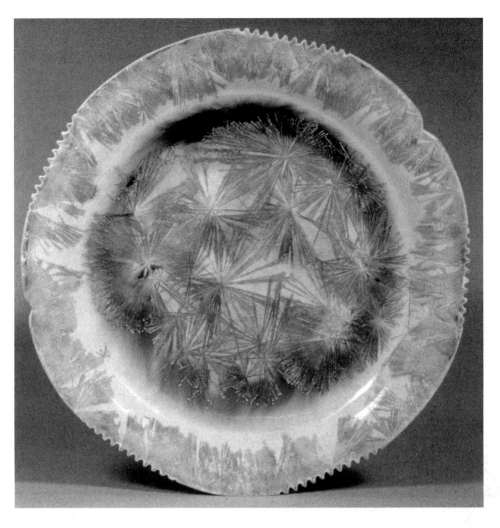

Plate by Joyce Nelson, USA.

and had to find out more about the procedure. I thought it was something new and that this particular potter was the inventor. Little did I know, then, that the process had existed for over 100 years.

Since that first exposure, I have seen many different types of crystalline glazes. I still find the process intriguing, and I still want to learn more about it.

This book attempts to demystify the crystalline glaze process and provide the potter with an understanding of materials and knowledge needed to work in this medium. It's a starting point towards developing new and exciting glazes, and making beautiful pots.

Chapter One
History of Crystalline Glazes

Some say crystalline glazes were first made in the Orient many centuries ago. Ancient Chinese oil-spot glazes from the Sung Dynasty (AD 960-1279) contain very small crystals, but they may have been unintentional. Perhaps the potter was trying to prolong the cooling of the kiln, and the crystals developed accidentally.

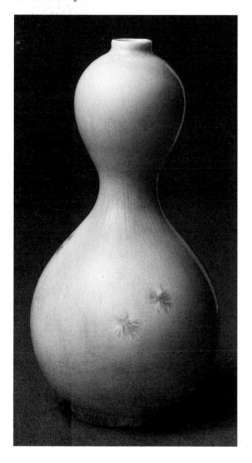

Development of crystalline glazes in Continental Europe

The history of crystalline glazing as we know it began in the 19th century. In Europe, it had been known for years that a glaze with an excess of zinc oxide would produce crystals.These crystals were considered firing accidents and of little interest. Most of the ware produced around the mid-1800s was very highly decorated with paintings or transfers of florals, animals and myriad other objects.

It was not until the development of the Art Nouveau movement that a more simple glazing style became popular. In large porcelain manufacturing companies throughout Europe, oriental glazes were being imitated. The single glaze on a simple form started to have an appeal, perhaps as a relief to the overdecorated work preceding it. Crystalline glazes, with their subtle colour variations, random occurrence and impressionistic appearance, better suited the natural and sensuous lines of the Art Nouveau style. Industrial ceramicists became interested in the feasibility of commercial production and began experimenting with these glazes.

Among the first scientists working on ceramics was Alexander Brongniart at the Sèvres National Porcelain Factory in France. Brongniart was the creator of

Porcelain vase made by the Royal Copenhagen Manufactory, *c.* 1900

European hard porcelain. He was succeeded by Ebelman who headed the manufactory from 1847 to 1852. Ebelman produced some crystalline glazes around 1850.

For the next 33 years after Ebelman left, there was little development of crystalline glazes at Sèvres. Then, on September 19, 1885, Charles Lauth and G. Dutailly supposedly donated a cup with a crystal glaze to the manufactory's museum. This cup and the date established the documented beginnings of crystalline glazes produced at Sèvres.[1] However, the Sèvres factory did not start formally producing crystalline glazes until 1897.

When Lauth and Dutailly discovered crystal deposits in glazes that were made with zinc silicate and titanium dioxide, they chose not to develop the procedure. Instead, they issued a warning to other chemists about these contaminants and how to avoid this particular 'problem'.

The factory chemist at the Royal Copenhagen Porcelain Manufactory, Adolphe Clement, disregarded the warning and began experimenting with zinc silicates in glazes. He published his results in a report to the Congress for Applied Chemistry in Vienna in 1898.[2]

The Royal Porcelain Manufactory became the first to market crystalline glazes. Clement's successor, a chemist named Valdemar Engelhardt, developed the glaze into an artistic

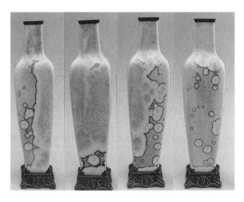

Above Vases from Sèvres National Porcelain Factory, France, 1901.
Left Two-handled vase by Pierrfonds, *c.* 1904-1910.
Below Sèvres plate designed by Taxile Doat. From a private collection.

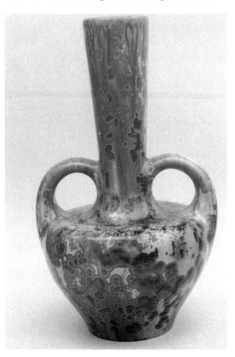

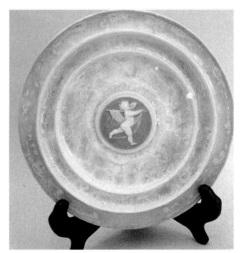

application. It was under Engelhardt that these glazes became internationally known.[3]

In Berlin, in 1878, the Techno-Chemical Research Institute became attached to the Royal Porcelain Manufactory. Albert Heineche, head of the Institute from 1888-1914, started concentrating on crystalline glazes around 1898.[4] Also at that time, Wilhelm Pukall, a chemist from the Royal Porcelain Manufactory, who was also head of the Royal Ceramic College, worked with crystalline glazes and published his results in 1908.

Meanwhile, at Meissen, Germany, crystalline glazes were first produced in 1898 and shown at the Paris Exhibition of 1900.[5] Also at the turn of the century, the Röstrand Porcelain Manufactory in Sweden started producing Japanese-style forms made of porcelain and earthenware that were crystalline-glazed.

Development of crystalline glazes in England

As information on the crystalline glaze technique became more widely known, the Royal Doulton Company and Pilkington's Tile and Pottery Company in Great Britain started experimenting with crystalline glazes. Pilkington's developed several different crystalline lines, one being 'Starry Crystal', so-called because of the jagged shape of the small crystals, and 'Opalescent Crystal', a milky opalescent with clusters of small matt crystals. Despite these innovations, Pilkington's became better known for their aventurine glazes – lower temperature matt glazes with tiny glittering specks suspended within. These glazes were more controllable and, therefore, more commercially viable.

Royal Doulton became internationally recognised for their outstanding achievements with crystalline glazes. At the Brussels Exhibition in 1910, every piece was sold within hours of the opening. They used a high temperature porcelain body fired to 2550°F (1400°C) and developed a crystalline glaze featuring larger, single crystals floating in a glassy background. With the outbreak of World War I, Doulton stopped producing crystalline glazes because they were very expensive and the technique too unpredictable.

The porcelain manufacturing factories in continental Europe also experienced financial problems with crystalline glazes. Because production costs for individually glazed pieces were relatively high, production was gradually cut back at all factories during the first decade of the 20th century. After 1910, in Germany, only the Meissen and Schwarzburg workshops continued to produce 'flow' and crystalline glazes.[6] To further reduce production costs, elaborately-moulded designs were replaced by mass-produced objects, and the complex glazes were replaced with simpler glazes that did not require such careful processing.

Development of crystalline glazes in the United States

In the United States, a crystalline glaze called 'Tiger-eye' was introduced in 1884 at the Rookwood Pottery in Cincinnati, Ohio. Rookwood Pottery achieved an international reputation with this glaze, and at the Paris Exhibition of 1889, they won a gold medal.[7]

The Fulper Pottery Company of Flemington, New Jersey may have been established as early as 1805. Initially, it made utilitarian ware such as crocks, filters and cooking utensils. In 1909, it entered the art pottery field with a more

diversified line called Vase-Kraft which was decorated exclusively in ornamental glazes in gloss, matt, monochrome, lustre, and crystalline.[8]

Teco Pottery in Illinois was originally the art pottery line of the American Terra Cotta and Ceramic Company, producers of sewer pipe, brick and terracotta. Early experimental ware was first glazed in reds, buffs and later browns. At the turn of the century Teco developed a matt green glaze called Teco Green which was used on organic shapes. Successful experiments led them into producing aventurine glazes and experimenting with crystalline glazes. By 1901, they had developed minute irides-

cent crystals and they became the first art pottery in North America to succeed in duplicating the large crystals developed earlier in Europe, thus predating the European pottery display at the St Louis Exposition in 1904. Teco Crystal, as the ware was called, was marketed nationally. No two pieces of Teco Crystal were alike. But producing this kind of ware on a commercial basis was too expensive, considering that these glazes were unpredictable. These designs were abandoned and once again the single Teco Green glaze dominated the line.[9]

The Robineaus
Taxile Doat was an artist-craftsman who worked at Sèvres from 1879 to 1905. He wrote a series of articles which contained recipes for his glazes and working

Three-handled vase by the Fulper Pottery Company, c. 1920. Everson Museum of Art, Syracuse, USA. Photo by Courtney Frisse.

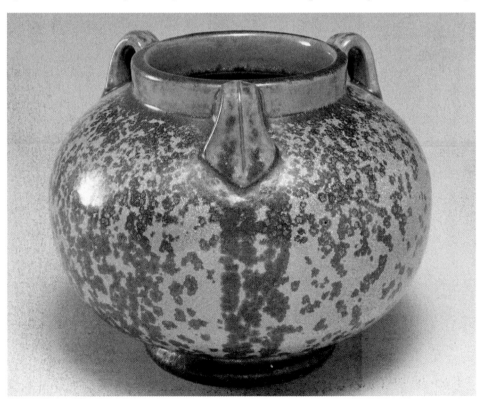

procedures. This work was published by an American couple, Samuel and Adelaide Alsop Robineau of Syracuse, New York in their magazine *Keramic Studio*. Samuel Robineau, a Frenchman, translated the material to English. *Grand Feu Ceramics* was later published by the Robineaus in 1905.[10] In America, at the turn of the century, sources of information about crystalline glazes were few, making Doat's book a valuable contribution to American potters who wanted to work at higher temperatures with porcelain.

Adelaide Robineau was influenced by the high temperature porcelains produced at Sèvres and the Royal Copenhagen Porcelain Manufactory. She published an article in the 1901 issue of *Keramic Studio* on the Royal Copenhagen porcelains which included crystalline glazes. Robineau started to work mainly in porcelain and experimented widely with glazes, making her first crystalline-glazed piece in 1904.[11]

In 1910, Robineau and her husband were invited by Edward G. Lewis, founder of the American Women's League, to join the University City Pottery at St Louis, Missouri. Taxile Doat was brought over from France to head the School of Ceramic Art. This was an opportunity for the Robineaus to work with a great master in an ideal setting, with all materials supplied and an annual income. Financial difficulties, however, plagued the University City venture. After a year, the Robineaus returned to Syracuse, where Adelaide continued to make pottery and teach at Syracuse University until her death in 1928.

Competition among the porcelain factories of Europe was keen. Chemists kept most of their recipes and methods of working a secret, which necessitated American potters conducting their own research and experiments. The American Ceramic Society was formed in 1896, comprising a group of ceramicists working in industry, universities or for the government. When a discovery

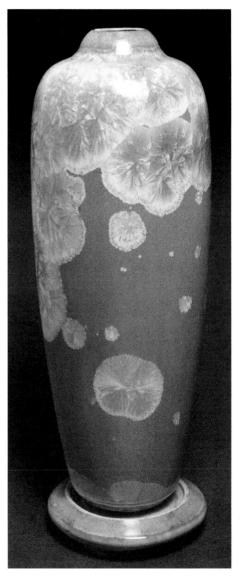

Vase with stand by Adelaide Robineau c., 1910. Everson Museum of Art. Photo by Courtney Frisse.

was made, results were published in their magazine *Journal of the American Ceramic Society*.

Several articles on crystalline glazes were published in their magazine starting in 1904. Glaze recipes were listed, and potters were encouraged to experiment with these new glazes. F. H. Norton was one frequent contributor to the magazine, writing several articles on crystalline glazes. In 1937, he presented a paper to the society entitled 'The Control of Crystalline Glazes'. Norton's experiments produced crystals at desired locations by seeding, and he was also able to control the size and shape of crystals by varying time and temperature.

Crystalline glazing in the 20th Century

Attitudes towards pottery were beginning to change with the advent of the 20th century. Until then, people were strongly influenced by the Industrial

Below
Jar with cover by Adelaide Robineau, 1919. Everson Museum of Art, Syracuse, USA. Photo by Courtney Frisse.

Right
Porcelain bottle by Derek Clarkson, England, 10 1/2 in. h.

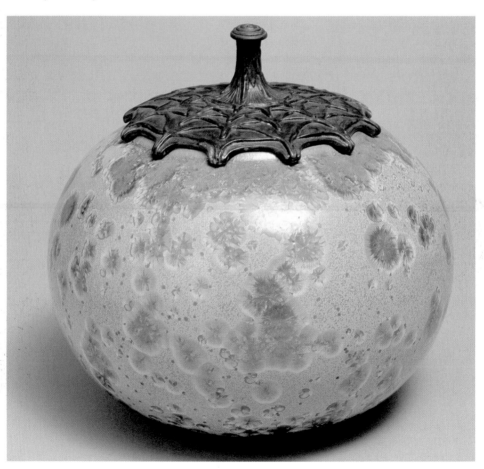

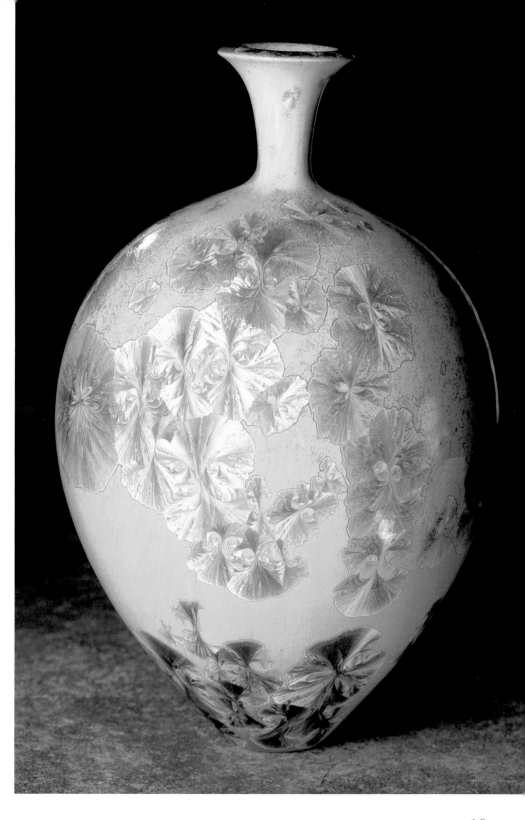

Revolution, and an artist was considered an overseer, directing the production of his designs. He made the model or drawing of the object to be moulded or cast, then the parts were subsequently assembled. Usually he was responsible for one aspect of the work, be it carving the prototype or glaze painting the designs. Others would mix the clay, cast or throw and trim the piece, perhaps glaze it, and definitely fire it. The artist-designer allowed others, or perhaps a machine, to produce his concept.

By the turn of the century, crystalline glazes were gaining popularity in Europe

and North America. These new glazes were suited to simpler shapes, so much of the former embellishment was changed for a simpler style. Cylinder, bottle, gourd or oval was now the popular form, and form without decoration influenced the rising Arts and Crafts movement.

The idea of artist-potter changed dramatically during the 1920s and 1930s. Individual potters now performed nearly all the production processes. They dug and pugged their own clay, designed and made the pot, then glazed it and fired it in their own personally-constructed kilns. They strove for excellence based on a tradition rather than that of an artist singularly striving to express a personal vision. The factories could mass-produce

Globular vase by Herbert Sanders, 1966. Everson Museum of Art, Syracuse, USA. . Photo by Courtney Frisse.

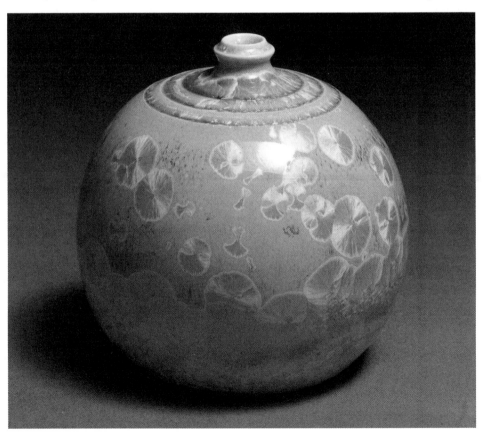

the functional ware; folk art could no longer compete, but the artist-craftsperson became a means of defence against the materialism of industry and its insensibility to beauty. Perhaps the beginning of this change of attitude, at least in Britain, came with the arrival of Bernard Leach from Japan, in 1920.[12]

Leach's attitude toward the individual artisan influenced others in Great Britain and continental Europe. On his return to Britain from Japan, he was accompanied by Shoji Hamada, an accomplished Japanese potter. Leach and Hamada established a pottery at St Ives, Cornwall, England. They used natural local materials for their clays and glazes, allowing impurities in these materials to give character to the work. Several of Leach's students or assistants went on to establish their own potteries. Hamada returned to Japan, where he set up a pottery similar to the one at St Ives. He became world-renowned for his pottery and was later declared a National Treasure in Japan.

The Arts and Crafts movement was also growing in the United States. Clay became an acceptable medium for making art. Alfred University established its School of Clayworking and Ceramics in 1900, and with pottery-making now being taught at the university, credibility came to the craft. No longer were potters trained only to go into industry as designers. Now the idea of the individual artisan doing all aspects of the work became accepted in North America too.[13]

Charles Fergus Binns, founder of the School of Clayworking at Alfred University, influenced the way his many students approached their craft. Binns stressed the importance of the individual potter assuming responsibility for all steps in the process. The division of labour associated for so long with production potteries of the previous century was no more.[14]

Binns was strongly influenced by the Oriental glazes produced in China during the Sung Dynasty. He believed that potters should mix their own glazes to enhance the individuality of the pot. His experience in formulating glazes led to a fascination with crystalline glazes. Adelaide Robineau attended a ceramics course at Alfred University taught by Binns whose influence and encouragement undoubtedly led her to formulate glaze recipes of her own.

Herbert Sanders should also be recognised for the work he did with crystalline glazes in the 20th century. He studied at Ohio State University, where he received the first PhD in ceramics in the United States. He began researching crystalline glazes while at Ohio State and developed his first glaze recipes in 1931. He went on to become an important educator and researcher, teaching at Ohio State, Alfred University, and California State University at San José. He wrote a book called *Glazes for Special Effects*, which has several chapters on crystalline glazing.[15]

Marc Hansen was a student of Herbert Sanders at San José. He formulated his own frits (using them as part or all of the glaze) and maintained a very high standard for his work. He developed some extremely beautiful crystalline glazes. Much of his interest, research and efforts went towards perfecting glaze colours. He also went on to become an educator, teaching at Western Michigan University.

Studio potters

Studio potters have been working with crystalline glazes for about the last 50 years, some obtaining remarkable results. Workshops and symposiums

have been offered in this glaze procedure, and some potters use crystalline glazing exclusively. Ceramic magazines such as *Ceramic Review* (England) and *Ceramics Monthly* (USA) have published articles on this type of glazing. Many new discoveries and experiments have taken place with crystalline glazes, allowing this glazing method to become widely recognised.

The International Symposium of Crystalline Artists, founded in 1982, consisted of 20 potters who exchanged data on crystalline glazes in a newsletter. The group disbanded in 1988.

A show of crystalline-glazed pottery produced by potters living in Belgium, East and West Germany, France, the Netherlands, Austria and Switzerland took place in 1987, in Hohr Grenzhausen, West Germany. Twenty-six potters participated. The show received international attention and published a catalogue that featured the artists and their work.

In 1993, Derek Clarkson, a British potter, organised a show at the Manchester Art Gallery in England. Historical crystalline pieces were featured together with the contemporary works of studio potters from England, Europe, the United States, Canada and Japan.

Today, many individual studio potters thoughout the world produce one-of-a-kind crystalline-glazed pottery. Most find their own unique way of working with crystals and have developed their own glazes and firing procedures, the methods being as varied as the crystals themselves.

Notes

1 Keramikmuseum Westerwald. *Kristallglasuren*, Kreisverwaltung des Westerwaldkreises, Montabaur, 1987, p. 13.
2 Fäy-Hallé, Antoinette (translated by Barbara Mundt). *European Porcelain of the 19th Century*, Rizzoli International, New York, 1983, p. 260.
3 Bodelsen, Merete. The *Royal Copenhagen Porcelain Manufactory 1775–1975*, Copenhagen, 1975, p. 66.
4 Fäy-Hallé, Antoinette , op. cit., p. 260.
5 Charleston, Robert J. (ed.). *World Ceramics*, Hamlyn, London, 1968, p. 304.
6 Fäy-Hallé, Antoinette , op. cit., p. 262.
7 Charleston, Robert J. (ed.), op.cit., p. 313.
8 Evans, Paul. *Art Pottery of the United States: An Encyclopedia of Producers and Their Marks*, Charles Schribner's Sons, New York, 1974, p. 110.
9 Ibid., p. 280.
10 Weiss, Peg (ed.). *Adelaide Alsop Robineau: Glory In Porcelain*, Syracuse University Press, Syracuse, New York, 1981, p. 95.
11 Ibid., p. 77.
12 Charleston, Robert J. (ed.), op. cit., p. 314.
13 Perry, Barbara (ed.). *American Ceramics, The Collection of the Everson Museum of Art*, Rizzoli, New York, 1989, p. 121.
14 Ibid., p. 121.
15 Ibid., p. 177.

Chapter Two
Crystals from Nature

Grains of salt, hunks of coal, diamonds, snowflakes – throughout history, there has been a fascination with natural crystals. Crystals have been valuable in many aspects of daily life. Mining and smelting of iron, copper, bronze, lead and silver crystals probably dates back 4,000 years. Crystals have played an important role in religious and healing ceremonies, been imbued with mystical powers, and used to forecast the future. In a more conventional sense, they have served as trading commodities and body adornment.

From the earth's beginning to the present, crystals have been forming naturally. But what is a crystal? Simply put, a crystal is a substance whose molecules are arranged in three-dimensional, recurring patterns.

Crystals will form in a cooling or evaporating solution under certain conditions of temperature and pressure.

The earth's crust covers a very hot interior. Gravity and other geophysical forces cause magma to form. When magma rises to the surface, volcanos spew it out as molten lava. While the lava cools, it creates a rich environment for the growth of crystals. When a solution such as magma is heated to the point of melting, its molecular structure breaks down and molecules move at random. As the temperature of the solution increases, more molecules can be added, and the solution becomes

Crystal formations in rock. Miller Museum of Geology, Queen's University, Ontario. Photo by Michael Barrett.

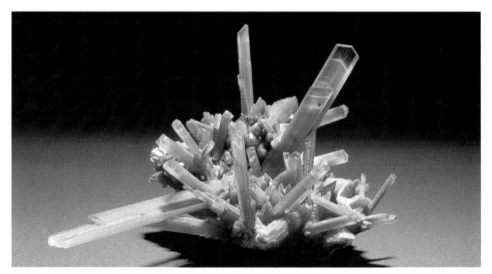

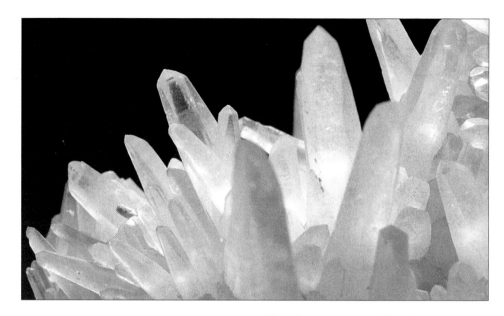

Quartz crystals. Miller Museum of Geology, Queen's University, Ontario. Photo by Michael Barrett.

supersaturated. When the solution cools, it becomes unstable and can no longer contain these excess molecules. It must 'dump' the excess, thus forcing molecules out of the solution where they re-form into regular, repeat patterns. When the material solidifies, or freezes, it is now in the crystalline state.

Supersaturation can also occur when a solution becomes concentrated by evaporation. Again, excess molecules can no longer be contained. Whether the driving force is heating, cooling or evaporation, excess molecules will align themselves with seed crystals present in the solution, and the crystals will grow larger. *Note:* Unlike most materials which have melted then cooled, glass cools and solidifies without a crystalline structure forming. Some consider glass to be in a liquid state even after it has cooled, since the molecules in glass are arranged at random.

When conditions are right, crystals may start growing in many different locations within a solution. They continue to grow until something foreign gets in their way or until they get in each other's way. Most crystals appear in clusters and most rocks contain several different kinds of crystals, of various shapes and sizes. Some crystals are so small that a powerful microscope is needed to see them. Others are as huge as a box-car. Regardless of size, crystals of the same mineral have the same structure.

Small crystals form where cooling occurs rapidly, usually on the surface. As rain washes the surface, erosion takes place. Crystals break down and become even smaller. Freezing and thawing occur, shattering rocks and breaking up crystal arrangements. As ocean water recedes, salt pools on shorelines evaporate, leaving salt crystals.

Larger crystals develop where cooling takes place over a longer period of time, usually beneath the earth's surface. When rocks are buried, they are sub-jected to heat and pressure. They can change their crystalline form, re-crystallise, and become a different mineral. Examples include limestone changing to marble and graphite becoming diamond.

The beautiful, natural shapes of crystals have piqued the imagination of scientists who have used crystals in numerous practical innovations. They have also been an inspiration to potters who have captured the essence of natural crystals by developing and working with crystalline glazes.

Chapter Three
Crystals Grown under Controlled Conditions

Crystals play a large part in today's world of technology. From the accurate splitting of seconds with advanced time-keeping instruments to the launching of a space craft, we depend on crystals. Radios, televisions, telephones and computers all incorporate crystals. Auto ignitions, miniaturized hearing aids, pacemakers, and many other devices contain solid state components, which are chips of single crystals. Crystals help regulate power supplies to our cities and control our mass transportation systems. They are used in ultrasound equipment and lasers for diagnosing disease. Credit card and bank transactions also depend on crystals.

There are not enough natural crystals available to satisfy the needs of technology. Natural crystals have become too valuable, may not be the right size or shape, or may not be pure or perfect enough. Because of this, most crystals used by industry are grown in commercial laboratories to suit specific needs.

A potter can also grow crystals, using appropriate glaze recipes and a kiln to control heating and cooling. These crystals can vary from spectacular individual forms to crystalline matts. In traditional, non-crystalline glazes, the molecules are arranged at random. These glazes are characterised by a smooth, glossy surface. The glaze feels and looks like glass. However, glass contains almost no alumina and is of low viscosity, or runny when molten. Traditional glazes must be fairly stiff and not run off the pot when molten. So alumina is added to increase viscosity (the non-running quality of the glaze) and help the glaze adhere to the pot.

Unlike traditional glazes, crystalline glazes contain very little alumina because it would be difficult for crystals to form in a stiff glaze. Like glass, the glaze must be fluid so that crystals can separate, align and grow. Most crystalline glaze recipes contain zinc oxide, silica, and an assortment of fluxes. Zinc oxide and silica, the most prominent ingredients in the recipe, combine to form crystals of zinc silicate (Zn_2SiO_4). Zinc silicate crystals formed in nature are known as willemite.

The growing pattern in a crystalline glaze is similar to frost forming on a

Orderly alignment of crystal patterns.

windowpane. Growth starts from a nucleation point and spreads outward in an orderly manner. Seed materials (nuclei) provide sites for crystal development. The molecules in the solution attach to the seeds to form rods or fibres, each of which is a single crystal. The fibres coming together fan outwards, creating the distinct crystal shape.

Size of crystals is influenced by two factors – the rate of cooling in the kiln and the amount of seed material in the glaze. When a crystalline glaze cools rapidly, smaller crystals tend to form. A glaze that cools slowly promotes growth of larger crystals. But, when many nuclei are present, growing crystals crowd each other, resulting in a smaller size. Fewer nuclei provide more space and allow each individual crystal to grow larger. Regardless of size, crystals grown from the same oxides and seed material will have the same internal structure and physical properties.

A window of approximately 130°F (72°C) exists in which to grow crystals. In the hotter part of the growing range, zinc silicate fibres line up beside one another, producing thin, needle-like crystals. As the temperature drops into the cooler end of the growing range, the fibres fan out and crystals become spherical.

It is important to determine the maximum and minimum temperature limits in the crystal-growing range. If the temperature is too high, few or no crystals

Detail of a crystal by Peter Klube, Germany.

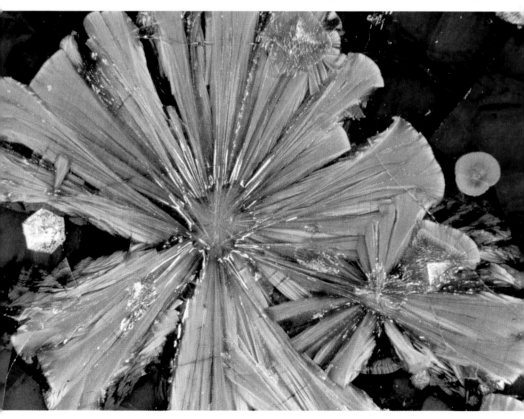

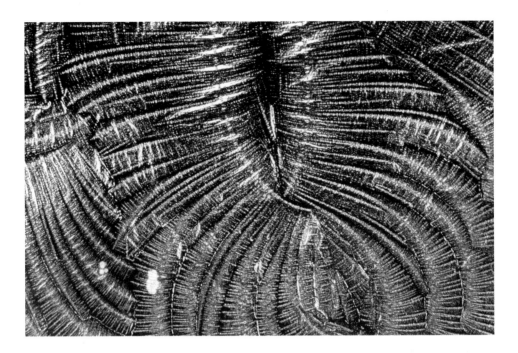

Detail of a crystal by Peter Klube, Germany.

will form. If too low, the glaze becomes solid. Once temperature limits have been determined, the temperature should be held constant to allow crystallisation to take place. As the temperature cools further, the glaze itself will thicken, become gel-like, then solidify or freeze. Every glaze has its own freezing point, but the crystal growing range for zinc silicate crystals is about the same. It is necessary to keep accurate notes in order to determine these important temperatures.

With traditional glazes, the melting point is the approximate maturing temperature of the glaze and represents the uppermost temperature to which the glaze will be fired. By contrast, a crystalline glaze is fired higher than the melting temperature of the glaze, in order to liquify the glaze completely. This higher temperature could be at least 400°F (222°C) hotter. Once this point is reached, the temperature should be quickly reduced to the temperature range for crystal formation, then held for a predetermined time.

The temperature range for growing crystals is wide enough that most potters can expect some degree of success. However, if you wish to grow a specific shape or size of crystal, you must determine your parameters through careful testing and record keeping. Methods for growing crystals in specific shapes are described in greater detail in Chapter Ten.

Chapter Four
Types of Crystalline Glazes

For the purpose of discussing crystalline glazes, I have divided them into two groups: microcrystalline and macrocrystalline. Microcrystalline glazes contain crystals that need magnification in order to be seen. Macrocrystalline glazes have crystals we can readily see.

Microcrystalline Glazes

Microcrystalline glazes contain crystals in great quantities, but the crystals are visible only under magnification. Almost the whole mass is crystalline, with small amounts of glass present as support. When light strikes the surface of the glaze, it is broken up by these tiny crystals, reflected and scattered in all directions. The surface is usually a pleasant, soft, satin matt. These glazes may be fired either in reduction or oxidation and do not require slow cooling. Zinc oxide, rutile and titanium aid the crystal formation. Although these matt glazes have a crystalline structure, their recipes are not included in this book. They are considered traditional glazes, since they are fired in a traditional manner. If you were to refire these matt glazes to a slightly higher temperature, they would remain matt, because of the crystals present.

Just because a glaze is matt does not necessarily mean it contains crystals. Any glaze not heated sufficiently will produce a matt finish but it will appear dull and lack the soft, satiny feel of crystalline matts. An underfired glaze will take on its true characteristics if refired to a higher temperature, perhaps becoming glossy.

Macrocrystalline Glazes

These glazes produce a large variety of crystal shapes and sizes. There may be only a few individual crystals on the pot, or the entire surface may be covered with crystals. They can be divided into the following four categories:

Low-temperature crystalline glazes
These crystals can be produced at low temperatures (earthenware). They tend to be small and usually cover the entire surface of the pot. There is no need to take the temperature beyond the melting point, nor is there a need to hold or maintain the temperature. Once maximum temperature is reached, the kiln is turned off and allowed to cool, although a slow cooling for the first 390°F (216°C) is suggested. If the temperature is dropping too fast, the elements can be turned on to a low setting to slow down the cooling. After the initial controlled cooling, the kiln is allowed to cool naturally.

Aventurine glazes
The name 'aventurine' comes from mineralogy where it designates a type of feldspar containing 'flitters' of hematite (iron). Aventurine glazes produce single

crystals, often small, but separated and easily observed. They are suspended in transparent glazes and can catch and reflect light. The crystals form when there is an excess of one or more metallic oxides in the glaze, which dissolve in the glass magma during the firing process. During firing, the glaze or glassy matrix liquefies. As the kiln cools, the capacity of the glassy liquid to hold its dissolved material in solution decreases, and the excess is deposited as crystals within a glassy matrix. Most aventurine glazes are made with iron (usually 10–15%), but they can also be obtained with chrome, uranium, nickel and cobalt oxides. Cooling is usually slow, to allow the crystals to grow. It is not necessary,

however, to hold or soak the temperature of the kiln, as must be done with typical crystalline glazes.

Crystalline matt glazes
There are many matt glazes in which crystals are clearly visible. Some of these glazes are designed for low temperatures, some for high temperature oxidation, and others for high temperature reduction. I will call these glazes 'crystalline matts', to distinguish them from matts which require magnification in order to be seen.

Large individual crystals
The crystalline glazes with which most of us are familiar often contain large, well-developed, distinct crystal patterns immersed in a glassy matrix. The crystals sometimes reach a size of 3–4in. (7.5-10cm) across, but they are usually much smaller. These crystals are the general topic of this book.

To achieve many crystals is relatively simple, but to have just a few large, individually placed crystals on a piece requires experimentation and skill, or tremendous good luck.

The visible crystal shape we see is not really an individual crystal, but rather an orderly arrangement of many small needle-like crystals which have placed themselves in a particular pattern to resemble the crystal shape. This shape is determined by both time and temperature.

It takes time and experimentation to get to know how to use crystalline glazes well. There are so many variables.

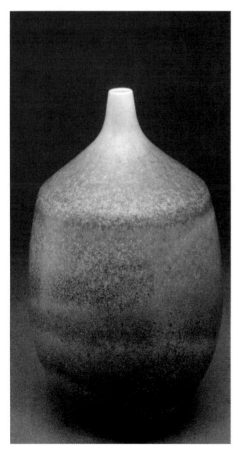

Left
Bottle by John Tilton, USA, 8in. x 4in., matt crystalline glaze.

Right
Vase by Louise Reding, USA.

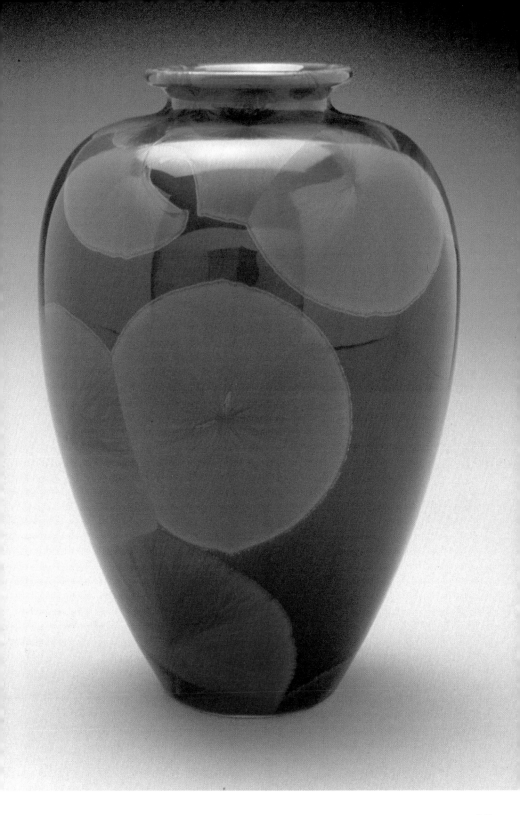

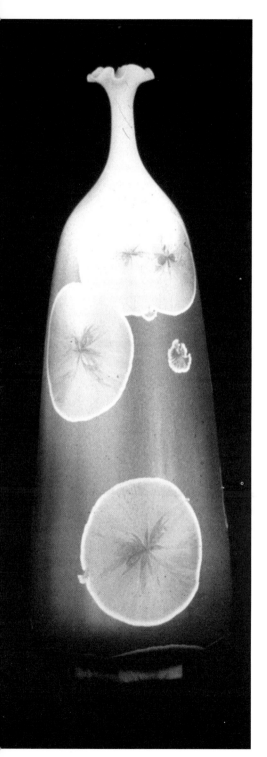

I suggest that one glaze recipe be used at a time. Learn the characteristics of that glaze, its firing range, and the effect of adding colouring oxides to the glaze. Experiment with the form of the pot and how it relates to the glaze. A common problem is using too many glazes and knowing none of them well.

Left
Bottle by David Snair, USA.

Below
Detail of the alignment of crystals in a crystalline glaze. 20x magnification.

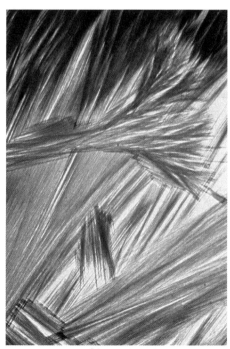

Chapter Five
Clays and Forms

Clay bodies

The preferred clay for crystalline glazes is porcelain. Porcelain is characterised by its whiteness and translucency and there is a quality to porcelain, not apparent in other clay bodies, which enhances the richness and vitality of crystalline glazes. That is not to say that other clays cannot be used. At lower temperatures (earthenware), crystals tend to be very small and cover the whole surface of the pot. Their variety is limited and the results are unspectacular. Therefore, I wouldn't recommend using crystalline glazes on earthenware unless you are restricted by your kiln to the lower temperatures.

Stoneware offers more possibilities for growing a variety of crystals than earthenware. It is also suitable for crystalline matts and aventurine glazes. Note however that with macrocrystals, darker stoneware may show through a transparent glaze, or iron particles from the clay body may become nucleation sites.

Semi-porcelain and white stoneware are the best choices for crystalline matts

Plate by Paulette Neau, Canada.

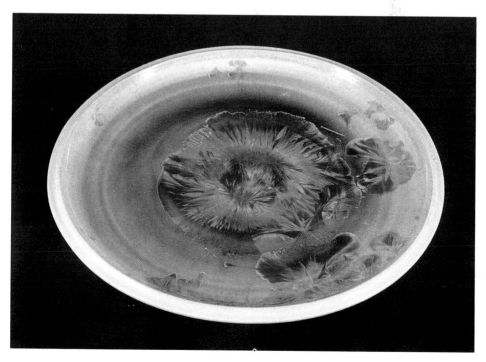

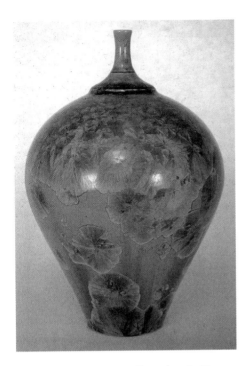

Bottle with copper crystalline glaze by Tony Menzer, USA.

the chosen firing temperature helps prevent the surface of the clay body being dissolved by the glaze. An immature clay body is less translucent, but since the walls of a crystalline-glazed pot tend to be made thicker, translucency is not a factor.

Usually 40–50% of a porcelain clay body is made up of non-plastic materials – namely silica and flux – making it somewhat difficult to work. Therefore, various ingredients such as ball clay, kaolin or bentonite are added to porcelain to increase plasticity. Allowing porcelain to age also increases plasticity.

Before deciding on a clay body, run a series of tests on several different compositions, as some clays produce nicer results with crystals than others.

and, in some cases, may be used for the macrocrystallines as long as the clay is smooth and fine.

Porcelain though gives a brilliance and sparkle to crystalline glazes that other clays cannot offer. Its colour is whiter and its particle size is finer. The absence of grog or other large-grained materials reduces scratching during trimming. Scratches, or the raised surface of granular material, can provide unwelcome nucleation sites for crystal formation.

Crystalline glazes can dissolve the surface of a clay body during the melt. Alumina from the clay body can be absorbed by the glaze, causing it to go matt or opaque. Also, certain ingredients in the fired porcelain may enhance or diminish the fluxing of the glaze. Using a clay body which is slightly immature at

Form

Aventurine and crystalline matt glazes are not as fluid as crystalline glazes. Therefore, no precautions against their running need be taken. Since these glazes do not have a tendency to pool, they can be applied to most forms.

With flowing crystalline glazes, more glaze must be applied to the pot so an even wall thickness which allows for even absorption of glaze and presents fewer areas of stress in the structure of the piece should be used. Also, a thicker-walled pot allows more glaze to be absorbed and a wet glaze to dry without running or peeling off the pot.

Strong forms with smooth flowing surfaces are best for crystalline glazes. Pronounced throwing lines should be avoided because glaze gathers in the crevices. Vases and bottles, because of their convex shapes and elegant outlines,

Right

Bottle by David Snair, USA.

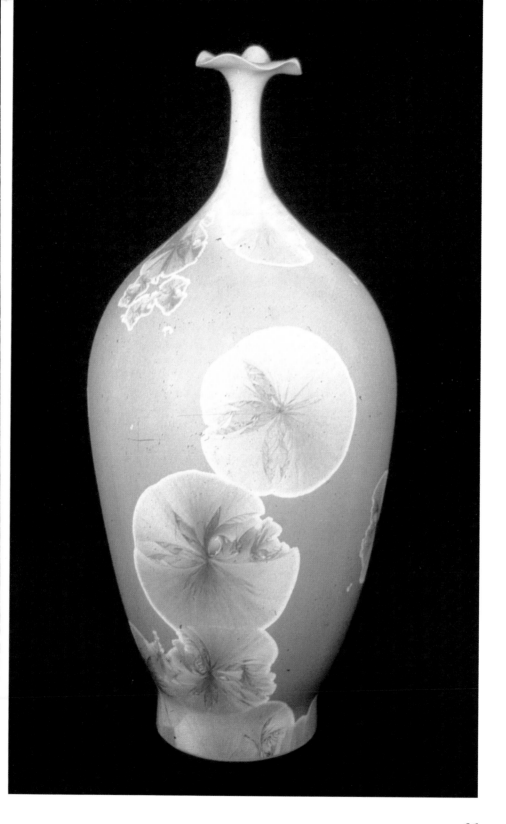

are most suitable. Their vertical structure also allows the glaze to run smoothly, without pooling. The form of a piece may influence the general pattern of crystals. On vertical areas, glaze can flow down the walls of the pot in an even application. On flatter areas, or interiors, glaze tends to pool, sometimes to a depth where it may look rough and opaque, or resemble a puddle of glass.

Surface decoration should be kept to a minimum. The glaze is full of detail, and to add further decoration might produce a busy appearance. Because of the richness and elegance of crystalline glazes,

the form should also be elegant and graceful. It's not the kind of glaze to put on a coffee mug.

Recommended porcelain clay body recipes are given in Appendix Three.

Right, above
Hand-built organic form by Mimi Dann, USA.

Right, below
Open bowl by Joyce Greenhill, USA, 10in.w x 3in. h.

Below
'Moonlight Sonata', bottle by Margaret Edwards, New Zealand, 8½in. x 7in.

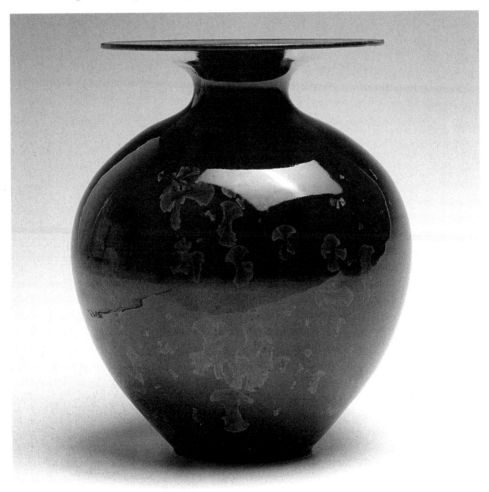

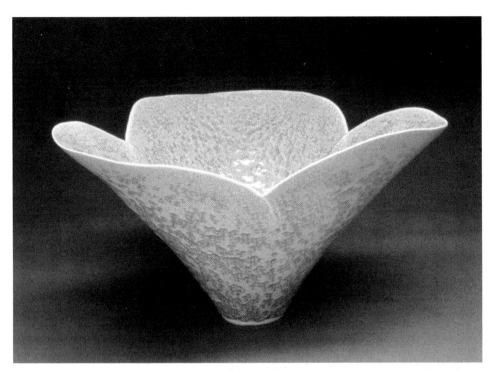

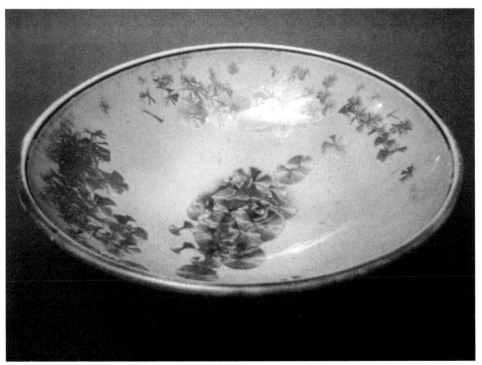

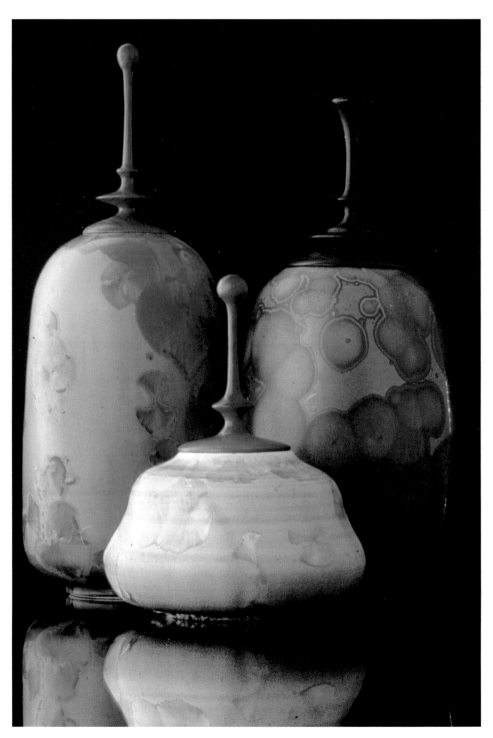

Bottles all with hand-turned wooden stoppers by Mary Ichino, USA. Photo by Gary Miyatake.

Chapter Six
Ingredients in a Crystalline Glaze

A macrocrystalline glaze recipe is usually made up of approximately 50 parts frit, 25 parts zinc oxide, and 20 parts flint. Other materials, in lesser proportions, may be added to alter the character of the finished glaze. Knowing glaze ingredients and how they react to each other is essential for understanding crystalline glazes.

Ingredients in a crystalline glaze

Frit

A frit is a manufactured compound that has been fired to a molten state, cooled, then ground to a powder. Using a frit in a glaze simplifies glaze preparation. One single, convenient material is added, rather than having to weigh out and add several ingredients.

A frit, when used in a crystalline glaze recipe, lowers the overall melting temperature of the glaze ingredients. It is also used to convert water soluble glaze ingredients into insoluble complex silicates. Using a frit ensures that a homogeneous glaze coating remains on the surface of the clay body, not in the water, and that no soluble material is absorbed by the clay body where it could act as a flux.

When using lead compounds, commercial frits are formulated to balance lead in the correct ratio to silica, for

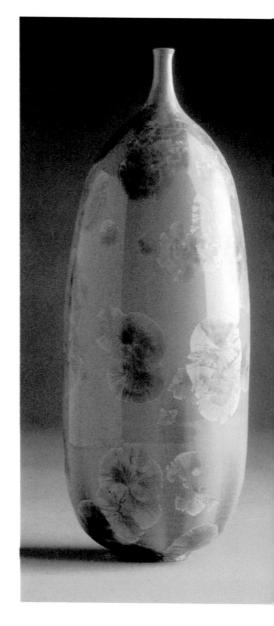

Bottle by Diane Creber, Canada, 10½in. h.

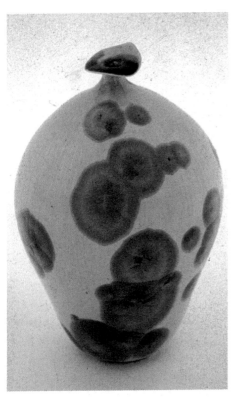

specific temperatures. This process renders the lead non-leachable and safe to use for commercial application.

Before frits were commercially available, potters either used unfritted material or made their own frits. Certain frits may be difficult to obtain, not available commercially, or perhaps the potter wishes to make all aspects of the glaze. A crystalline glaze made without a frit usually must be used immediately and should not be stored.

Certainly some potters still choose to make their own frits. Here is how it is done.

A crucible (smelting pot) is made from high-alumina fireclay and fired to cone 10. Ingredients to be fritted are weighed

Left
Bottle by Laura Schlien, USA.

Below
Vase by Roslyn Reed, Canada, 12in. h.

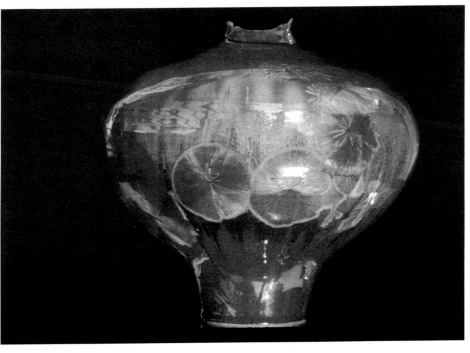

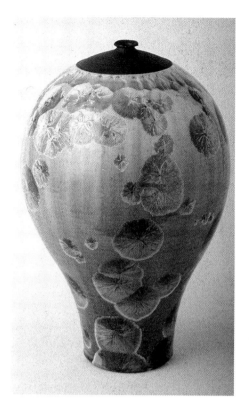

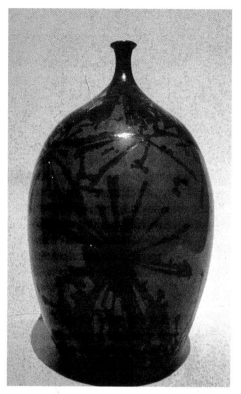

Above
Bottle by David Williams, Australia, 12in. h.

Above, right
Bottle by Antonio Vivas, Spain.

out, dry mixed, sieved through an 80s mesh screen, then placed in the crucible from the kiln. The red-hot liquid is either poured into a tank of water or a plug is removed and the liquid flows into the tank. On contact with water, the materials quickly freeze and shatter into glass fragments. This material is strained, then ground in a ball mill until it can pass through an 80s mesh screen. The frit must be washed to remove the alkalines, salts and soluble sulphur.

These potentially dangerous procedures demand extra safety precautions, including wearing protective clothing and safety goggles. Unless your studio has the facilities and you have experience with the process, the safety precautions and extra work required to make a frit renders this procedure impractical. Also, an extremely long grinding time in a ball mill is required to pulverise the frit to a suitable fineness. Because of the convenience, most potters rely on commercial frits.

Flint

Flint, commonly called silica, is known as quartz in its pure crystalline state. When melted and cooled, it readily forms a glass. In a crystalline glaze recipe, flint combines with zinc oxide to form crystals. It also enriches the colour of glazes. Because flint melts at an extremely high temperature (3120°F, 1715°C), it must be used in combination with fluxes.

Zinc oxide

Zinc oxide, at the middle and high temperatures, is an active flux. When used to excess in a glaze low in alumina and cooled slowly, zinc will produce crystals. Zinc and flint have an affinity for each other and will readily combine to form zinc silicate (Zn_2SiO_4). In its natural state, this ingredient is known as willemite. Increasing the zinc content increases the number of crystals. However, too much zinc in a glaze recipe produces too many crystals, resulting in a matt glaze.

Right
Bottle by Barbara Cauvin, Australia, 11½in. x 4in.

Below
Covered jar by Don Holloway, USA.

Alumina

Alumina is added to a glaze recipe to give viscosity, making the glaze less likely to run off the pot when melted. Used in very small amounts, it helps the finished glaze adhere to the pot in a uniform thickness. Alumina levels in a crystalline glaze should be kept very low

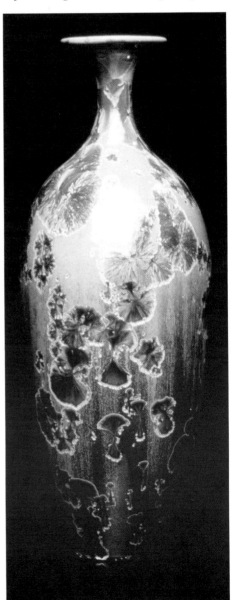

as alumina has a tendency to produce many crystals, resulting in a matt texture. Alumina in glaze is usually introduced as kaolin.

Titanium dioxide and rutile

Titanium dioxide, used in amounts up to 5%, encourages crystal growth. It also acts as a colour modifier, producing brilliance and purity. If the percentage of titanium dioxide is increased beyond 5%, the glaze becomes matt.

Rutile is an impure oxide of titanium and contains small amounts of iron. It is sometimes substituted for titanium dioxide to promote crystal growth.

Other oxides

Sodium, lithium and potassium oxides are active fluxes which dissolve other oxides and contribute fluidity to the glaze.

Calcium, barium and magnesium oxides are sometimes added to crystalline glazes. They give lustre and elasticity.

Boron reacts like alumina, impeding the growth of large, isolated crystals.

All of these oxides can be added directly to a glaze. More often, they are added to the base glaze in the form of a frit.

Colourants

Metals which act as colouring agents may be added to glaze recipes in small amounts. The colour may be absorbed by the crystal, the base glaze, or both to produce contrasts of colour. One or a combination of two or more colouring oxides can be used in the glaze. Cobalt carbonate, copper carbonate and manganese dioxide are three colourants I use

Bottle by Peter Frolich, Austria, 27in. h.

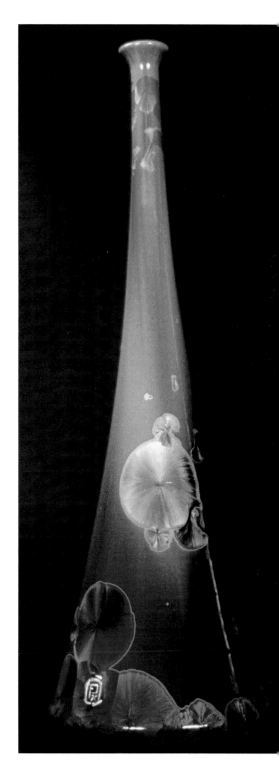

often. Oxides of these elements produce too strong a colour. The carbonates are more subtle. Rutile and the oxides of iron, chrome, nickel and uranium also provide interesting results. Some colourants seem to concentrate more in the crystal than the background. Generally, as the amount of colourant is increased, the background colour will become more intense.

Colouring oxides in amounts up to 8%, and sometimes more, of the total dry weight of the glaze recipe can be added. When two or more colourants are used, concentrations of each should be reduced. Colourants can be added to the dry batch or mixed with a little water, passed through an 80s mesh screen and added later.

The following is a list of colourants, with their concentration ranges given as a percentage of dry weight. The colour each produces is shown:

cobalt carbonate	0.5% – 2%	blue
copper carbonate	1% – 4%	green
manganese dioxide	1% – 5%	pinkish tan
manganese carbonate	2% – 4% (has a lower melting temperature than manganese dioxide)	pink
red iron oxide	1% – 4%	yellow to green
nickel oxide	1% – 2%	green
rutile (dark)	1% – 4%	yellow

Stains

Some colours such as pink, peach, lavender and purple are difficult to achieve in a crystalline glaze. Commercial stains may be an answer, but they require extensive testing because ingredients in a stain may enhance or discourage crystal growth.

Covered jar by Susan Bunzl, Germany.

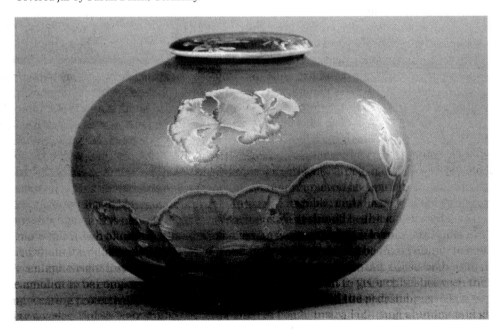

Stains can be used in the following ways:

1 Mix the stain with your porcelain clay body and strain through an 80s mesh screen. Add water to make a glaze-like consistency and brush the mixture onto the wet pot just after forming. Once the pot is bisque-fired, apply the crystalline glaze. The underlying stain colour will show through the glaze.

2 Mix the stain with water and brush onto the bisqued pot. This application will be uneven. Intensity of colour will depend on the amount of solution brushed on and the amount of water used. Apply the crystalline glaze on top. The stain shows through with colour variations.

3 Mix about 5% or less of the stain with the dry glaze batch. Mixing two or more stains together will further increase the variety of colours.

Calcining

Calcining is where a glaze ingredient is heated to the temperature at which chemically-combined moisture is driven off. The purpose of calcining is to reduce shrinkage by burning off organic soluble salts.

Zinc oxide can comprise about 25% of a glaze recipe and it has a high shrinkage rate. So, zinc oxide and kaolin are the ingredients usually calcined. If glaze peels off the pot as it dries, or crawling occurs, calcining is recommended.

Put dry-sieved material to be calcined in an unglazed bisque-fired bowl, and take it to bisque temperature. Temperature is not critical (1760°–1885°F, 960°–1030°C). Substitute the calcined material for zinc oxide and kaolin in the glaze recipe. To calculate for weight loss by calcining,

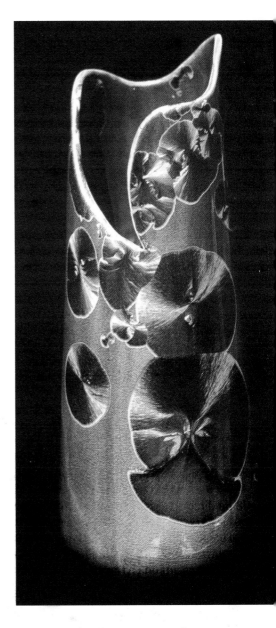

Vase by Joyce Nelson, USA, 13in. h.

pre-weigh the material. Weigh after calcining and calculate the difference. This gives a percentage weight loss and determines the amount to be compensated for.

Ingredients in aventurine glazes

Aventurine glazes can range in firing temperatures from cone 010 to cone 10. At lower temperatures, some of the glazes may call for a frit. Those that contain unfritted materials usually have lead as a flux. Therefore, for health and safety reasons, they should not be used in ceramics intended for serving food.

At higher temperatures, glazes usually contain feldspar, whiting, china clay or kaolin (the alumina), and a frit. Boron can be added to increase fluidity, but should only be used in small amounts or it may retard crystal formation. Flint also reduces fluidity.

Usually, iron is the principal oxide in aventurine glazes (10–15%). It is added to a transparent, very solvent base glaze. Other colouring oxides can be used including chromium, nickel and manganese oxides.

Ingredients in chromium glazes

Chromium produces crystals at lower temperatures, although the crystals tend to be quite small. Also, it is possible to obtain red crystals using chromium.

Lead, the main ingredient in chromium crystal glazes, usually comprises 75–80% of the glaze. Red lead works better than litharge or white lead. Flint is around 10% or less of the glaze. Whiting is a source for calcium and a major flux. Wollastonite, a natural calcium silicate, can be added to replace flint and whiting. The alumina content, which is usually introduced as kaolin, should be kept low. It is important that there be no zinc in the glaze, or the colours will turn muddy.

Bowl and plates by Caroline Whyman, England.

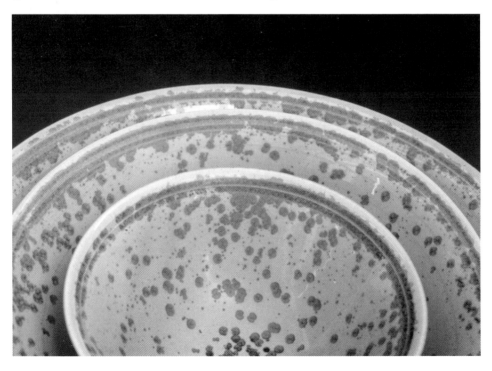

Chapter Seven
Glazing

How each of us glazes is a personal matter. We develop methods and approaches which are best-suited to our surroundings and our own methods of working. Experimentation must take place if an artist is to develop and grow. Careful note-taking and record-keeping are essential.

Before glazing begins

Crystalline glazes are going to run. Zinc silicate glazes are notorious for ruining kiln shelves. However, there are several ways to protect kiln shelves from glaze and produce finished pots with smooth, glaze-free bottoms.

In his book *Glazes For Special Effects*,[1] Herbert H. Sanders suggests attaching the foot rim of a pot to a pedestal made of insulating firebrick. He uses #2400 porous brick when firing to cone 10 and #2600 brick when firing to cone 12. He saws the brick, then files or grinds it to fit the foot rim. The brick is easily ground by rubbing it against a concrete block or a cement floor.

Next, Sanders cuts a 13mm ($1/2$ in.) slab from the porous brick. Both pedestal and brick are covered with two to three coatings of kiln wash composed of 50% china clay or kaolin and 50% silica, mixed with water to a slurry consistency. The slab is placed on the kiln shelf, and

Details of bowls by Caroline Whyman, England.

the glazed pot on its pedestal is placed on the slab, being sure the foot rim of the pot lines up with the edges of the pedestal. Excess fluid glaze runs down the pedestal onto the slab, thereby protecting the kiln shelf. After firing, the pedestal is ground away from the bottom of the pot.

The pieces of brick must be completely covered with kiln (bat) wash. Glaze can eat into brick, dissolve it, and cause the pot to topple. When using this method, I prefer to make my pedestal larger than the foot rim so the pot will be stable. Instead of using a brick slab to collect excess glaze, I make a stoneware dish, placing both pot and pedestal into it. The dish holds excess glaze better than

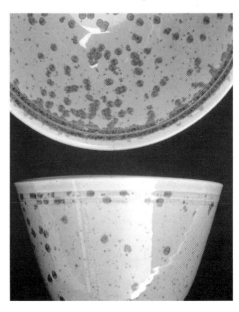

a brick slab, and the glaze does not eat into the dish as it might with brick.

In an article in *Ceramics Monthly* called 'Making and Firing Crystalline Glazes',[2] David Snair describes the following method to allow for fluidity of the glaze: Using the same clay as the pot so that there is no shrinkage differential, Snair throws a fitted ring or pedestal to match the dimensions of the foot rim of the pot. After bisque firing, the foot rim of the pot and the top of the pedestal surfaces are ground flat with emery cloth to insure a tight fit. The two pieces are joined with a paste of white glue and alumina hydrate thinned with a few drops of water. A tight fit is necessary to insure that no glaze will seep into the seam. A bowl made from groggy clay can be used to contain the glaze pool at the base of the pot. After firing, bowl and foot rim are separated from the pot by tapping with a sharp chisel just below the seam.

I have adopted Snair's method, with some variations. To make the process simpler, I trim all foot rims of similar sized pots to the same diameter. This way, when making the pedestal, I have a standard size for foot rims and can make the pedestals one-size-fits-all. The foot rim should have a sharp edge to allow close contact between pot and pedestal. Otherwise, glaze may run under a rounded edge, making removal more difficult.

Since the collection bowl is going to be discarded, it can be crudely made. It can even be a pinch pot, as long as it is stable, and the pedestal does not wobble. It should be thick, since it may end up containing a lot of glaze. Sides of the dish should be high enough to contain excess glaze but not so high as to make it difficult to get a chisel between the foot rim and the pedestal.

Instead of using alumina and glue to

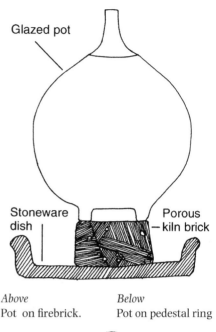

Above
Pot on firebrick.

Below
Pot on pedestal ring

attach the pedestal, I mix china clay or kaolin with glue. I find kaolin dries faster than alumina, creates a better bond, and allows the pot to separate from the pedestal as well, if not better, than alumina.

The glued-on pedestal makes a good handle when applying glaze.

Making the glaze

When making glaze, work in small batches of about 1000g (or less) dry weight. Keep the work area clean and free from contaminants. Accurately weigh out ingredients using a triple-beam balance scale. Mix ingredients with a small amount of water to make a slurry. Pass the slurry through an 80s mesh screen twice to break up any coarse particles and to thoroughly mix ingredients. Add a little water to the screen, and push the slurry through using a kidney or wire brush. Add more water, if necessary, but remember that the glaze should be applied thickly.

The addition of a flocculant such as magnesium sulphate (epsom salts) retards settling of ingredients in the glaze and also allows you to stir the glaze more easily after it has settled. An amount of around 0.25% of the glaze ingredients, dissolved in hot water, is sufficient and has no apparent effect on the finished glaze.

Bevan Norkin (Virginia, USA) adds up

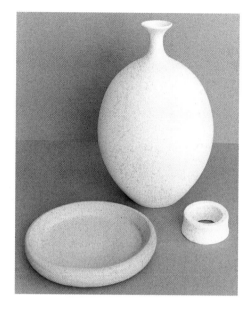

Above
Bisque fired pot, pedestal and collection dish.

Below, left
Glue is applied to the pedestal, which is then applied to the pot.

Below, right
Pot and pedestal sitting in the collection dish.

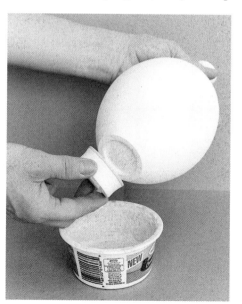

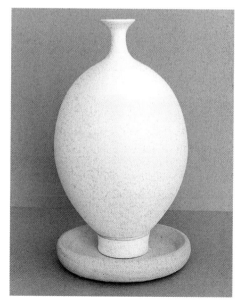

45

is affected by a colouring oxide. A standard colour progression test should be done for each particular glaze to determine exact percentages most suitable for each colour additive.

To conduct a colour progression test,

Progression test.

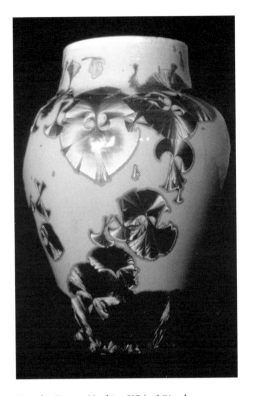

Vase by Bevan Norkin, USA, 10in. h.

to 3% bentonite or bentolite L plus 2% lithium carbonate to the dry weight of his glazes. Doing so reduces the amount of water required to make up the glaze. More importantly, it creates a near perfect suspension of glaze ingredients prior to application. A perfect suspension means that the glaze has the same distribution of seed nuclei on the pot as in the container.

If you are applying glaze over a mature-fired pot, gum tragacanth (the consistency of molasses or golden syrup) can be added to the glaze to prevent it from running off the pot during application. In my experience though, re-firing a pot seldom gives as good a result as the first firing.

Glaze tests should be conducted to see what the recipe is like and how the glaze

mix 100g of dry base glaze with water. Place 10g of the colouring agent on a piece of paper in a small pie-shaped pile. Use a knife or straight-edge tool to segment the pile, first in half, then in quarters. Take one quarter of the pile and divide it by half, then divide the half into two equal parts. Starting with the smallest section, add to the base mix and do a test sample. Add each of the

Susan Bunzl's thrown porcelain shape for glaze testing.

segments in turn, making a test sample with each addition.

Testing the glaze on a flat tile is ineffective. These are flowing glazes and should be fired on a vertical form. Susan Bunzl (Germany) has developed a unique method for testing her crystalline glazes. She throws a bowl shape with a turned-down rim, then turns it over so it resembles the shape of a hat. The rim catches the overflow of glaze, and she can test several glazes on each bowl.

Application of the glaze

First the bisqued pots are cleaned with a damp sponge to remove dust. The glaze must be constantly stirred to keep ingredients from settling. Glaze can be applied by dipping, brushing, pouring or spraying. I first brush on the glaze, then dip the top section to allow for a more even coating of glaze and to build up a thicker application on the top. It is important to apply the glaze thickly. There must be enough glaze to allow for running and to develop crystals. It may take several coats of glaze to build up an adequate thickness. Crystalline glazes consist almost entirely of insoluble materials, which make them easier to apply thickly. However, when insoluble materials dry, they have no dry-strength and require careful handling.

When glazing a bowl shape, precautions must be taken or glaze will run and pool on the inside. I apply glaze heavily around the rim area of the bowl, allowing it to get thinner as it gets closer to the middle, so that at the bottom there is only a thin application. When the piece is fired and the glaze runs, there should be an even layer of glaze all over. Glaze can also be sprayed on with the applica-

tion getting thinner towards the bottom. Deciding on thickness of glaze application comes with experience.

When glazing a plate, the glaze should be thinner than what would be put on a vertical form. Use a standard production glaze designed for the cone temperature on the outside of the plate. Care must be taken around the rim of the plate where the two glazes meet. Contact should be prevented, or else the crystalline glaze might run over the top and into the regular glaze.

For items like vases and covered jars, a standard functional glaze should be put on the inside. A glossy white or clear glaze works well. Only the outside is glazed with the crystalline glaze. Without precautions, the lid of the jar could become fused to the body of the pot. Since the glaze will not run as much on a flat surface, lids should be flat and not curve downwards on the edges. The glaze should be applied more thinly on the lid.

Because crystalline glazes are decorative, they should be reserved for decorative pieces. The roughness of some crystals, where they pool on the interior, make these glazes unsuitable for the inside of food containers. A standard glaze should be used instead.

Plate by Flora Christeller, New Zealand.

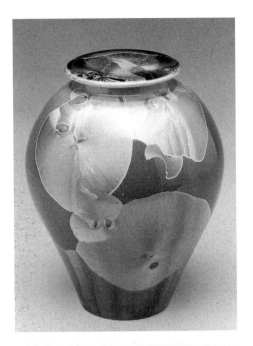

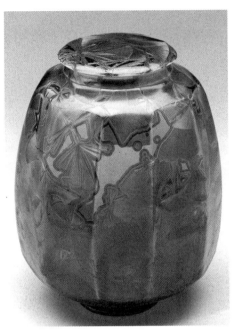

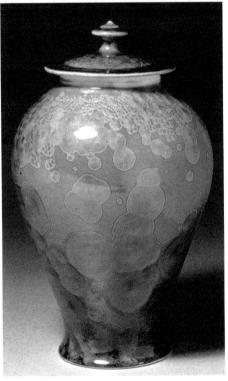

Above
Jars by Diane Creber, Canada.

Seeding

To 'seed' a crystalline glaze is to add
more nuclei to insure crystallisation
occurs. Also, to some extent, placement
of the crystals can be controlled by seed-
ing. Ingredients that remain undissolved
at the liquidus temperature can act as
nuclei (seeds). They need not be the
same ingredients as in the glaze recipe.
Titanium dioxide, granular rutile,
ilmenite, cadmium, molybdenum, tung-
sten, zinc oxide and zinc silicate can be
used as seeding agents. Experiments are
necessary to determine the amount of
seeding material to add to a specific
glaze. Each seeding agent will act differ-
ently. Start by adding 0.5% to the glaze,
then increase the additions by 0.5%
until you have the effect you want. Too
great an addition will give a matt,
rough appearance.

Covered jar by Frank Neff, USA.

Crystals can also be placed on specific areas of the pot through seeding. This can be done in several ways:

1 The pot is glazed with a clear glaze that contains no seeding agents. It is placed in the kiln in front of a spyhole. A metal tube is inserted into the spyhole when the temperature reaches maximum, and the seeding agent is blown onto the melted glaze. Then, the firing proceeds as a regular crystal firing.
2 The pot is glazed with a crystalline glaze, minus seeding agents. The seeds are either pressed into or glued onto the glaze before firing. The fired pot will be clear of crystals except in the specific areas where seed nuclei were applied.
3 Seeding agents can be glued onto the bisqued surface of the pot. Then, a crystalline glaze, without seeding agents, can be sprayed over the top. Crystals will appear only where seeding agents were applied.

I have never had much luck with any method of seeding and prefer to use a crystalline glaze that will become crystalline without enhancement. When experimenting with seeding, I found it difficult to achieve an area free of crystals. Either dust in the kiln or particles on the surface of the clay body have acted as nucleation sites. More likely, the glaze itself combined with the alumina absorbed from the clay body and together they created the nuclei.

Crystal enhancers

Crystal enhancers can change the shape of crystals, speed up crystal formations or increase their growth. Some enhancers make crystals look more pronounced. Different ingredients will give different results. Enhancers should only be used in small amounts, usually under 1%.

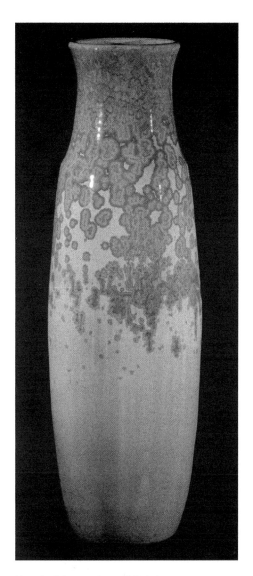

Vase by Maurice Lenaif, Belgium.

Molybdenum, cadmium and tungsten can change the crystal shape, while iron and manganese affect the crystal's growth. Experimenting with enhancers may give unusual and startling results.

Molybdenum
The molybdenum crystal is very elusive and unpredictable. When used in

49

amounts of around 5%, molybdenum produces small star- or rectangular-shaped crystals which are quite subtle. The matrix can be quite lustrous with rainbow hues. Sometimes the pot must be tipped to catch the light in order for the crystals to be fully appreciated.

In smaller quantities in a zinc silicate glaze, molybdenum promotes the formation of other types of crystals, sometimes becoming opalescent.

Notes

1 Sanders, Herbert H., *Glazes for Special Effects*, Watson-Guptill Publications, New York, 1974, p. 39.
2 Snair, David. 'Making and Firing Crystalline Glazes', *Ceramics Monthly*, Columbus, Ohio, Vol. 23-10, pp. 21-6, 1975.

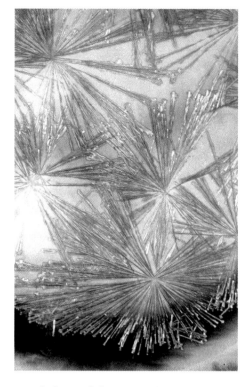

Detail of crystals by Joyce Nelson, USA.

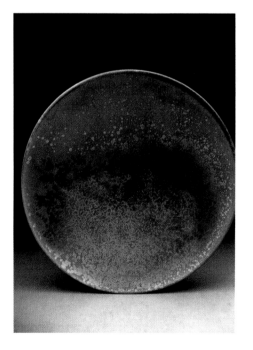

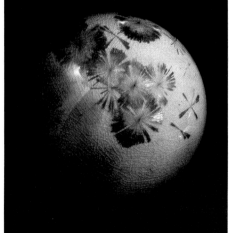

Above
Sphere by Leslie Ehrlich, USA, 3in. x 3in.

Left
Plate by John Tilton, USA, 14in. w.

Chapter Eight
Kilns

The biggest equipment investment a potter will make is the kiln. Selecting a suitable kiln to handle the work, achieve an even temperature, fire to desired temperatures with ease, and still be relatively safe is not always easy. Since everyone's needs will be different, finding a knowledgeable and reliable kiln distributor is important.

The truism 'you get what you pay for' is particularly relevant when purchasing a kiln. Buy the best kiln you can afford. There are many kilns on the market. You must know the quantity of pots that are going to be produced during a given time, the type of pottery being done, and your temperature requirements. Also, if you are planning to buy an electric kiln, know the amperage limit for your studio.

Some kilns come with variable heat dials. Others have bypassed the switch with a pre-set dial or a temperature controller which is built onto the kiln. This allows you to pre-programme the kiln, making it possible to pre-set a firing schedule. There are also programmable heat controllers that attach to and interface with the kiln. They allow you to choose or create programmes appropriate for your firing needs. These controllers vary from simple to complex. More about them in Chapter Nine.

Electric kilns

Crystalline glazes may be fired in fuel kilns, but today electric kilns are more frequently used.

Crystalline glazes, which are fired to cone 9 or above, require a kiln that can rise to this temperature quickly. The electric elements should accommodate fast firings to top temperatures. Fast firings are relative to size or volume of the kiln. Most potters require a kiln which can move production ware at a reasonable rate.

A kiln with a good element design is important for the extended soakings at high temperatures called for in crystalline firings. Kilns with a higher R factor will help reduce fuel costs, provide an even temperature throughout, and allow less heat to escape to the surrounding area, making the kiln a safer appliance. A well-insulated kiln will also cool more slowly, usually giving nicer looking glazes and the elements will last longer since they don't have to work as hard.

Because of the nature of crystalline glazes, a small research kiln (no greater than a cubic foot in volume) is helpful. David Snair, a potter who excels at crystalline glazes, stresses the importance of a small test kiln when working with crystals. Snair is able to do three or four firings a day in his ¾ cubic foot kiln. He believes a test kiln is essential when developing glazes and trying to solve glaze problems.

Electric kilns are usually either front-loading or top-loading. The front-loader is usually more expensive because of the bracing around the door, as well as the

reinforced door and hinge construction, plus flexible connections to door elements. Sometimes there may not be elements in the door section, which could create a cool spot. The top-loader, although cheaper, may be more difficult to load, especially if it is a deep kiln. It requires bending down into the kiln, causing strain on the potter's back.

If your kiln comes with a kiln sitter, the sitter indicates the maximum cone temperature being fired, then it shuts off the kiln. After this, it is necessary to bypass the sitter in order to turn the kiln on. For a sitter to be accurate, it must be set properly and maintained frequently.

You can also build your own kiln. The cost will be much less, and you can build to suit your requirements. There are excellent technical books on the market that deal with this subject. If you have technical skills and would enjoy such a challenge, building your own kiln is worth considering.

Kiln preparation and safety precautions

When you get a new kiln, read the hand-book carefully.

Placement of the kiln in the studio is very important. The floor under the kiln should be level and made of non-combustible material such as concrete or brick. The kiln should sit at least 12in. (35cm) from the nearest wall, and the wall should also be non-flammable.

Have a qualified electrician install the kiln, one who is experienced with wiring kilns. During installation, make sure the kiln is properly grounded. The kiln should always be disconnected from the power source before it is serviced. For the first firing, make sure all packing material has been removed. Fire the kiln empty up to its maximum temperature

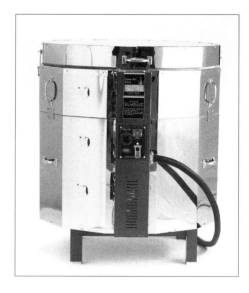

Kiln, top loading.

in order to set the elements. If this is not done, the Kanthal elements will contract from their recesses. The elements should also be oxidised as described in the owner's manual for a new kiln. This extends their life. Before loading or doing any work inside the kiln, ensure the power source has been shut off or disconnected. Keep the interior of the kiln clean. Vacuum the kiln and element grooves every few firings. The kiln should be in good repair and all elements working. Replace elements when they burn out or are no longer firing to full capacity. Long, drawn-out firings with weak elements can overfire ware and may seriously affect the results. Change all the elements at the same time if possible. This allows them to operate at equal intensity. Older elements lose their intensity. Replace crumbling or broken bricks.

Make sure the electricity is **off** when propping open the kiln door to do a rapid cooling.

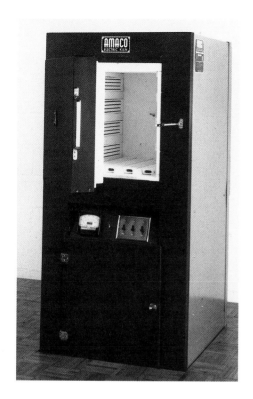

Kiln, front loading.

Do not exceed the temperature rating of the kiln.

When viewing the cones, protect your eyes from heat and visual glare by wearing welder's safety goggles.

Never leave a firing kiln unattended.

Loading the kiln

Since crystalline-glazed pots will be in a collection dish to catch overflow glaze, it is not necessary to kiln (bat) wash the shelves. If collection plates are not used, or there is a normal glaze on the outside of the pot and running is a possibility, kiln washing is recommended.

A recommended kiln (bat) wash for high temperature firings is 40% calcined alumina, 10% flint and 50% kaolin. - These ingredients are mixed with water

to a creamy consistency. Two or more coats should be applied with a wide brush, each application brushed on before the previous one is completely dry.

Keep the loading uniform. Avoid tight areas – they take longer to heat, hold their heat for a greater length of time, can radiate heat to each other, and may produce a hot spot on the ware.

Place the collection dish, with the pot on its pedestal in the middle of the dish, into the kiln. Make sure the pedestal is secure in the dish. A wobbly pot could topple over, taking several other pots with it.

Do not pack the kiln as tightly as you would a normal firing.

Use a three-point stacking system for support placement of shelves in the kiln. This facilitates using less kiln furniture and creates a more stable structure.

Some potters use no kiln shelves or furniture in a crystalline firing. This facilitates a faster heat rise and drop since there are fewer items to absorb or radiate the heat.

When using a top-loading kiln, place a kiln shelf over the top shelf if you are going to open the door when doing the heat drop. This will protect ware from materials which may fall off the door when it is opened.

Once the kiln is loaded and ready to fire, make sure you have:

- a long steel rod to prod open the kiln door if the kiln is a top-loader and is going to be opened during heat drop,
- high-heat safety mitts to protect hands from heat generated by the steel rod, and welders' goggles to protect eyes,
- a watch or sequential digital timer, and
- a notebook to record each kiln firing and the results.

Chapter Nine
Firing Aids

In Chapter Eight I suggested buying the best kiln you can afford. This advice also applies to firing accessories for the kiln. Usually, the better the equipment, the better the results – especially if you want to repeat certain firing patterns.

It is possible to produce crystals in a kiln that has a variable heat dial, using cones and a pyrometer. The results may be inconsistent, but with luck and understanding, you may also create some beautiful pots. If you are just starting to experiment with crystalline glazes and are using pre-established firing patterns, this equipment is satisfactory.

Simply having state-of-the-art equipment does not guarantee results. Using the equipment correctly, experimenting and keeping accurate records improve the chances for success. Starting with the barest essentials and moving to the most advanced equipment available, I will discuss firing aids on the market today.

Pyrometric cones

Regardless of what firing instruments you may have, pyrometric cones are necessary. Pyrometric cones are made of ceramic material similar to a glaze, which react to heat absorption by melting and bending when they have been exposed to a certain amount of time and temperature (heatwork). Cones can also indicate heat distribution in your kiln. Until you know your kiln well, there should be a cone

pack on every shelf.

Cones are numbered beginning at the middle point of 1 and increase 2, 3, 4 to 42. They also go down 01, 02, 03, and decrease to 022. Each cone number relates to a designated amount of heatwork done as influenced by time and temperature parameters. For example, Orton standard pyrometric cone 9 deforms at approximately 2336°F/1280°C given a heat rise of 270°F/150°C an hour.

Usually, cones are used in groups of three. They are placed in a cone pack which holds them at an 8° angle from vertical. The first cone is the guide cone. When it starts to bend you know the firing is close to maturity. The second cone is the firing cone and tells you that the desired heatwork has been reached. The third cone, the guard cone, displays an overfiring. A cone temperature is reached when a particular cone has deformed so the tip of the cone is even with the top of its base.

Cones are placed in line with the spyholes, making sure they are not placed too close to the elements. At red heat

Cone pack.

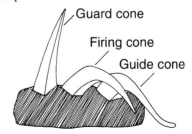

Guard cone

Firing cone

Guide cone

FOR ORTON PYROMETRIC CONES

These tables provide a guide for the selection of cones. The actual bending temperature depends on firing conditions. Once the appropriate bending cones are selected, excellent, reproducible results can be expected.

FOR ORTON PYROMETRIC CONES (°C)

Self Supporting Cones / Large Cones / Small — Cone Type and Composition
Heating Rate °C/hour (last 90–120 minutes of firing)

Cone	Regular 15	Regular 60	Regular 150	Iron Free 60	Iron Free 150	Large Regular 60	Large Regular 150	Large Iron Free 60	Small Regular
022		586	590	N/A	N/A	N/A	N/A		630
021		600	617	N/A	N/A	N/A	N/A		643
020		626	638	N/A	N/A	N/A	N/A		666
019	656	678	695	676	693				723
018	686	715	734	712	732				752
017	705	738	763	736	761				784
016	742	772	796	769	794				825
015	750	791	818	788	816				843
014	757	807	838	807	836				870
013	807	837	861	837	859				880
012	843	861	882	858	880				900
011	857	875	894	873	892				915
010	891	903	915	898	913	886	893	884	919
09	907	920	930	917	928	919	928		955
08	922	942	956	942	954	945	957		983
07	962	976	987	973	985	973	982	980	1008
06	981	998	1013	991	1012	995	1012	996	1023
05 1/2	1004	1015	1025	1012	1023	1011	1021	1020	1043
05	1021	1031	1044	1013	1023	1030	1046	1032	1062
04	1046	1063	1077	1043	1061	1060	1070	1044	1098
03	1071	1086	1104	1066	1088	1086	1101	1067	1131
02	1078	1102	1122	1084	1105	1101	1120	1091	1148
01	1093	1119	1138	1101	1123	1117	1137	1102	1178
1	1109	1137	1154	1119	1138	1136	1154	1146	1184
2	1112	1142	1164			1142	1162	1137	1190
3	1115	1152	1170	1130	1148	1152	1168	1151	1196
4	1141	1162	1183			1160	1181	1160	1209
5	1159	1186	1207			1184	1205		1221
5 1/2	1167	1203	1225			1201	1223		N/A
6	1185	1222	1243	1154		1220	1241		1255
7	1201	1239	1257			1237	1248		1264
8	1211	1249	1271			1247	1269		1300
9	1224	1260	1280			1257	1278		1317
10	1251	1285	1305			1282	1303		1330
11	1272	1294	1315			1293	1312		1336
12	1285	1306	1326			1304	1326		1355

Series groupings: SOFT SERIES (022–011); LOW TEMP SERIES (010–02); INTERMEDIATE TEMP SERIES (01–12)

FOR ORTON PYROMETRIC CONES (°F)

Self Supporting Cones / Large Cones / Small — Cone Type and Composition
Heating Rate °F/hour (last 90–120 minutes of firing)

Cone	Regular 27	Regular 108	Regular 270	Iron Free 108	Iron Free 270	Large Regular 108	Large Regular 270	Large Iron Free 108	Small Regular 540
022		1087	1094	N/A	N/A	N/A	N/A		1166
021		1112	1143	N/A	N/A	N/A	N/A		1189
020		1159	1180	N/A	N/A	N/A	N/A		1231
019	1213	1252	1283	1249	1279				1333
018	1267	1319	1353	1314	1350				1386
017	1301	1360	1405	1357	1402				1443
016	1368	1422	1465	1416	1461				1517
015	1382	1456	1504	1450	1501				1549
014	1395	1485	1540	1485	1537				1598
013	1485	1539	1582	1539	1578				1616
012	1549	1582	1620	1576	1616				1652
011	1575	1607	1641	1603	1638				1679
010	1636	1657	1679	1648	1675	1627	1639	1623	1686
09	1665	1688	1706	1683	1702	1686	1702		1751
08	1692	1728	1753	1728	1749	1735	1755		1796
07	1764	1789	1809	1783	1778	1747	1751	1800	1846
06	1798	1828	1855	1816	1852	1823	1854	1825	1873
05 1/2	1839	1859	1877	1854	1870	1852	1873	1868	1909
05	1870	1888	1911	1870	1873	1886	1915	1890	1944
04	1915	1945	1971	1909	1942	1940	1958	1911	2008
03	1960	1987	2019	1951	1990	1987	2014	1953	2068
02	1972	2016	2052	1983	2016	2014	2048	1996	2098
01	1999	2046	2080	2014	2052	2043	2079	2070	2152
1	2028	2079	2109	2046	2073	2077	2109	2095	2163
2	2034	2088	2127			2088	2124	2079	2174
3	2039	2106	2138	2066	2080	2106	2134	2104	2185
4	2086	2124	2161			2120	2158	2120	2208
5	2118	2167	2205			2163	2201		2230
5 1/2	2133	2197	2237			2194	2233		N/A
6	2165	2232	2269	2109		2228	2266		2291
7	2194	2262	2295			2259	2278		2307
8	2212	2280	2320			2277	2316		2372
9	2235	2300	2336			2295	2332		2403
10	2284	2345	2381			2340	2377		2426
11	2322	2361	2399			2359	2394		2437
12	2345	2383	2419			2379	2419		2471

© 1996 The Edward Orton Jr. Ceramic Foundation

Temperatures shown are for specific mounted height above base. For Self-Supporting - 1 3/4". For Large - 2". For Small Cones, 15/16".
For Large Cones mounted at 1 3/4" height, use Self-Supporting temperatures.

Orton cone chart

55

and above, they become visible. They can be used only once.

Cones are used to monitor heatwork based on temperature rise. To measure temperature drop and soaking temperature, potters must rely on other devices which indicate air temperature only.

Probes/thermocouples

The thermocouple (or temperature sensor) is a probe which is usually inserted near the midpoint of the kiln, several inches from the kiln wall. The thermocouple is made of two dissimilar wires fused together at one end. When the fused end is heated, an electromotive force is generated, and a voltage develops across the wires. This voltage is roughly proportional to the kiln temperature. Many analogue (needle type) or digital pyrometers will electronically convert the voltage measurement to the corresponding kiln temperature and then display the temperature directly.

For firings of cone 9 or less, a 'K' type or chromel-alumel thermocouple may be used. The chromel wire, which is the positive wire, is an alloy of approximately 90% nickel and 10% chromium. Alumel, the negative wire, is an alloy of approximately 94% nickel, 2% aluminium, 3% manganese, and 1% silicon. This type of thermocouple is relatively inexpensive, but at temperatures of cone 9 or above, it loses accuracy. The fusion point tends to oxidise, and it deteriorates rapidly at higher temperatures. It is not unusual to have an error of more than 25°F (14°C) when fired to cone 6 repeatedly. Cost effectiveness, however, favours using a 'K' type and replacing the thermocouple fairly often.

For high temperature or high precision firings (cone 9 or above), an 'S' type or platinum vs. platinum-rhodium

thermocouple is available. It is made of a positive wire containing 90% platinum and 10% rhodium and a negative wire of pure platinum. This thermocouple has a high resistance to oxidation and will indicate accurate temperatures up to about 2700°F (1480°C). Platinum-rhodium thermocouples are very expensive, but for high temperature and high precision firings such as crystalline glaze work, the 'S' type is recommended.

There are several factors that can affect the accuracy of a thermocouple-based temperature measuring system. Because thermocouple wires extend out through the kiln walls, they tend to conduct heat away from the tip. Thicker wires conduct more heat away (called wicking). Wicking, in turn, affects the response time of the thermocouple. The combined effects of wicking and slow response time can produce a temperature reading up to 36°F (20°C) lower than actual.

As the operating temperature increases, the thermocouple will vary from its accepted standard (tolerance). As a result, accuracy decreases. The more times the thermocouple is used, and the longer it is used at or near its recommended limit, the greater the chance of error.

Exposed thermocouples can also be affected by atmosphere. When materials present in the kiln react with the thermocouple wire, the composition of the wire is changed. The result is an error in the temperature measurement. Protection tubes are often used as a means to solve the problems caused by atmosphere. However, protection tubes can make the thermocouple slow to respond to heat adjustment, creating a difference between actual and reported temperatures. The tubes also have a wicking potential which may give a false

temperature reading of 18°F (10°C) less than the actual temperature.[1]

It is necessary to use a thermocouple-based temperature measuring system after initial cone temperature is reached and throughout the rest of the crystalline firing. If accurate records are kept and you learn what temperatures correspond to measurements taken, adjustments for discrepancies can be made.

Pyrometers

A pyrometer is a calibrating instrument attached by electrical wire to a thermocouple. Pyrometer systems are calibrated to indicate temperatures reached during heating and cooling.

The cost of a pyrometer is very reasonable. They are practical instruments for use with bisque and glaze firings that do not require the degree of accuracy which is needed for crystalline glazes

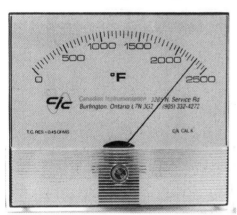

above
Pyrometer

below
Thermocouple.

Most scales on pyrometers are small, and a gradual change of temperature is hardly noticed. Indeed, a significant temperature change may occur before the potter reacts and makes necessary firing adjustments. Therefore, for crystalline glaze firings, an instrument which gives a greater degree of accuracy is recommended.

Digital thermometers

Digital thermometers are temperature-indicating devices which display temperature readings digitally. They attach to a thermocouple and can convert the voltage output to a readout in temperature, either in Fahrenheit or Celsius. Differences in temperature are indicated to within a percentage of a degree, so even the slightest change in temperature is immediately noticeable.

These devices are designed for specific thermocouple junctions so it is important that the readout be matched with the thermocouple wire being used. Thermocouple sensors can be placed throughout the kiln, and because this instrument can be handheld, it can be plugged into and unplugged from one thermocouple to another in order to compare various areas of the kiln. For accuracy it is essential to maintain both connections at the same temperature. A digital thermometer is more expensive than a pyrometer, but its faster response to temperature fluctuations allows temperature adjustments in the kiln to be made sooner than would be done with a pyrometer.

Temperature-holding pyrometers

These devices operate much like a thermostat on an oven or heating unit. The

desired temperature is set by the operator, and the temperature-holding pyrometer will maintain a soak (heat/time plateau). Most of these pyrometers also have an automatic temperature shut-off.

For a crystal firing, this instrument is set at maximum temperature (which should be backed up by cones) and the pyrometer will take the kiln to that temperature. Then, it will shut off. The operator must be present to turn the kiln back on after the temperature drop. Then, the pyrometer should be reprogrammed to allow the kiln to soak for the desired amount of time at a set temperature. The operator must shut the kiln off manually.

Voltmeters

These instruments are used primarily by electricians and electronic engineers to measure electrical current. They attach to the thermocouple wires and measure the voltage (which the thermocouple creates) in a visual display. The voltmeter can be very useful to potters because it is extremely sensitive to any change in temperature. Temperature changes are indicated immediately by a change in millivolts, allowing for temperature adjustments to be made. However, direct use of a voltmeter requires a known reference junction temperature such as

that of an ice bath. A slightly less accurate but acceptable procedure is to add the temperature of the room to the temperature determined by the temperature conversion scales published in literature dealing with specific thermocouples. Voltmeters can be purchased at most electrical supply dealers and are usually quite inexpensive.

With the preceding equipment, it is still necessary for the potter to make decisions and adjustments concerning the firing's progress. It is extremely difficult to repeat specific kiln firings using these manual instruments, although keeping accurate notes does allow for certain patterns to become obvious.

Electronic controllers

A great variety of electronic controllers are on the market today. Their functions can range from elevating the temperature at a prescribed rate up to a specific temperature, then shutting off, to a fully programmable computer-based data acquisition and control system.

A very useful instrument for crystalline glaze firing is a microprocessor-based programmable temperature controller with ramp and dwell features. A ramp is a heat rise or fall and a dwell is a soak over an interval of time. This instrument can be programmed to regulate electrical input (temperature vs. time) by a number of ramps and allows for various soaks and slow cooling cycles. Then it shuts off automatically. Some controllers are able to fire more than one kiln at a time, each with its own firing schedule. This type of controller also allows the operator to duplicate and repeat firing patterns, as long

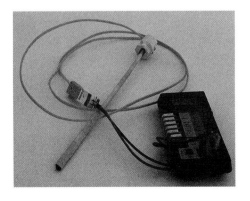

Voltmeter connected to pyrometer.

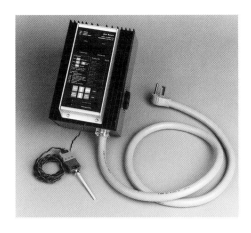

Electronic temperature controller.

as records are kept. Once the controller has been programmed and turned on, the operator makes no additional adjustments during the firing.

The more functions a controller can perform, the more it will cost. Even the simplest type is relatively expensive. If you are seriously interested in doing many firings with crystalline glazes, the investment in such a device should be considered. The technology provides freedom to pursue other activities, instead of sitting by the kiln during soak period, watching for any temperature changes. To be able to depend on this instrument for accuracy and duplication makes initial cost outlay worthwhile.

Kilns may be purchased with factory installed controllers or the controllers can be puchased separately and installed by an electrician. The controller must interface between the power source and the kiln's main switching panel.

Computers

It is now possible using a special software package for home computers to record data concerning kiln firings. During the firing, the actual time and temperature profile can be displayed, logged on your printer, and saved on disk, giving you a complete picture of the entire firing sequence. If you already own a home computer, then examining software programmes to record your kiln firings could prove valuable.

In industry, computers are used to operate complete kiln firings. Software applications can program even the most complex firing cycles. Several kilns, each with different firing schedules, may be operated at one time. However, because of expense, this firing system is still unavailable to most potters. But, as more computer advances are made, it may soon be possible that a data acquisition control board attached to a pyrometer will plug into a slot in your personal computer and operate your kiln automatically, with the program running in the background, leaving your computer free for other tasks.

There are many choices available on the market to facilitate kiln-firing schedules. The principal deciding factor is usually price. A simple pyrometer or voltmeter attached to a chromel-alumel thermocouple is within the budget of most potters. By comparison, a complete computer-driven system used for industry is beyond practicality. Knowing your needs, and what you can afford, will help you to make a selection.

Note

1 Vukovich Jr., Milan and Dale A. Fronk. *The Role of Pyrometric Cones and Temperature in the Firing Process*, The Edward Orton Jr. Ceramic Foundation, Columbus, Ohio, 1990.

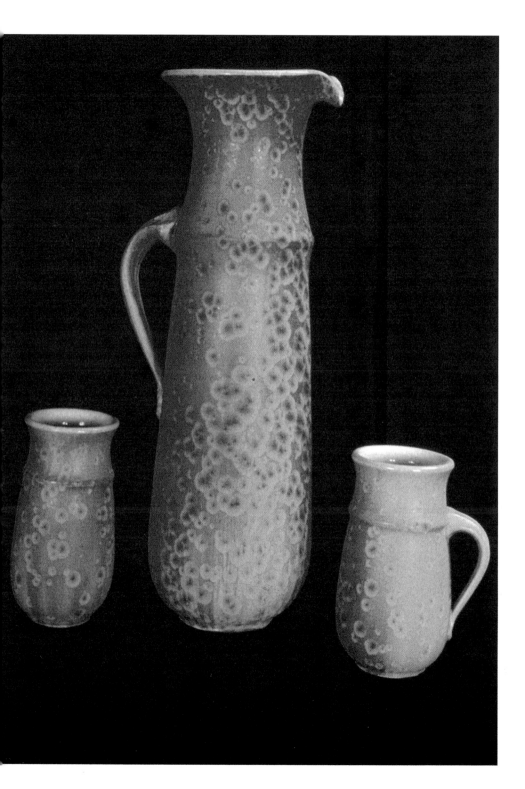

Chapter Ten
Firing Crystalline Glazes

When firing crystalline glazes, nothing should be left to chance or kiln gods. Having a complete understanding of firing procedures and keeping detailed notes are essential. Notes should include date of firing, glazes used, application techniques, thickness of glaze application, maximum air temperature and cone achieved, soak temperatures, time studies, and successes and failures. Creating graph profiles from time studies in a standard format provides a fast visual comparison. Time-temperature studies are tedious to do, but they add an understanding of the kiln's firing behaviour. Regardless of the characteristics of the kiln and the temperature being fired, firing profiles should be created.

The objective of a kiln firing is to create conditions which promote the growth of crystals. The sequence is:

- getting to maximum temperature as quickly as possible;
- rapidly cooling to the crystal growing range;
- extended soaking or slowly dropping the temperature during the crystal growth period, and
- shutting the kiln off and cooling naturally.

Left
Pitcher and mugs by Peter Frolich, Austria.

Right
Interior of bowl by Peter Lane, England.

Firing aventurine and low-temperature crystalline glazes

Aventurine and low-temperature crystalline glazes are fired to the maximum temperature suggested in the glaze recipe. Then the kiln is shut off and allowed to cool. With low-temperature crystalline glazes, a slow cooling is suggested. However, with aventurine glazes, it is not necessary to cool slowly. Both methods result in very small but distinct crystals.

Matt crystalline glazes

Peter Lane (Hampshire, England) and Hein Severijns (Reuver, The Netherlands) are two potters who work with crystalline matts on porcelain, using an

electric kiln. Both prefer the subtle blending of colour and the suggestion of depth and liveliness of matt glazes rather than large, flashy single crystals.

Lane fires a zinc glaze to 2300°F (1260°C), makes no attempt to hold the temperature, shuts the kiln off, and allows it to cool naturally. His pieces have many, very small crystals over the entire surface.

Severijns follows a more complicated cooling pattern. He quickly fires the kiln to 2336°F (1280°C), drops the temperature to 2066°F (1130°C), holds for three hours, drops to 2012°F (1100°C) for three hours, two hours at 2138°F (1170°C), one hour at 2084°F (1140°C), one hour at 2048°F (1120°C), and then a normal cooling. His results are distinct crystal patterns scattered over the surface of the pot, on a silky matt background.

Macrocrystalline glazes, cone 9/12

It is difficult to write a program for crystalline glaze firings because each kiln will fire differently. Eccentricities are more exaggerated in high-temperature firings, because heat-rise curves tend to flatten out in larger production kilns. Here is the procedure I use to fire my kiln. Although it only applies to my kiln, it may be a helpful guide.

I turn the kiln on in the evening, with the spyholes open so that moisture and glaze fumes can be vented off without harming the elements. Around 600°F (315°C), both the physical water and most of the chemical water will have been driven off. I close the spyholes and turn the heat up to medium at bedtime.

Early next morning, I turn the temperature up to high. By mid-morning, maximum temperature is achieved, and soaking time occurs during the day when I am in the studio. The time from when glaze starts to melt until maximum temperature is reached should occur as quickly as possible. Kilns which require a long time to reach maximum may produce disappointing results. A slow climb in temperature allows interaction between glaze and clay body, permitting glaze to absorb alumina out of the clay. The result may be many small crystals, a matt glaze, or dull rough areas.

Once maximum temperature is reached, I allow the kiln to cool quickly to soak temperature. Soak temperature is the desired crystal growth range for a specific glaze recipe. Some potters remove the bungs and open the kiln door slightly, others just open the spyholes, and some let the temperature drop naturally. There are opposing views about whether quick cooling should result from a forced or a natural drop. I open the spyholes, and sometimes the door. Once the growth range temperature is reached, I turn the kiln back on, and the temperature is maintained or allowed to drop for a specified length of time at a very slow rate of cooling – one to two hours for smaller crystals, four hours or more for larger crystals.

With a more basic firing system (temperature measurement and control) which does not allow for a specific soak temperature, the temperature is allowed to drop, then is maintained within the crystal growing range. Once the soak time is over, the kiln is shut off and allowed to cool naturally.

Right
Bottle by Diane Creber, Canada, 10½in. h.

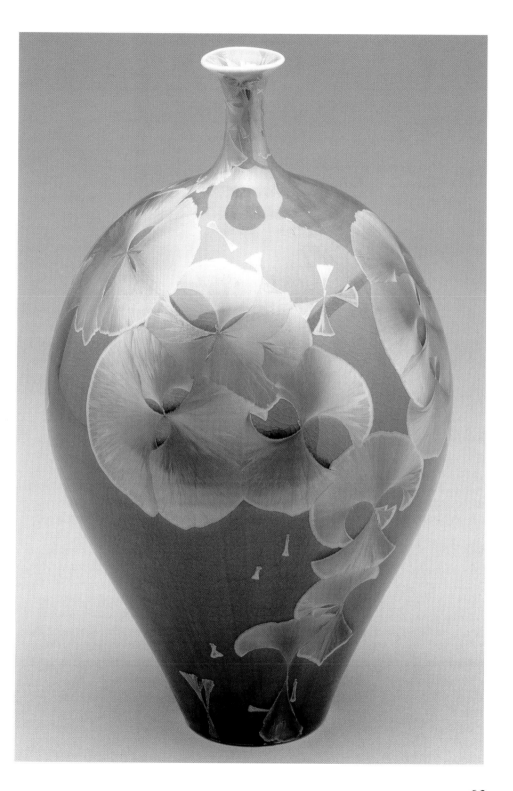

63

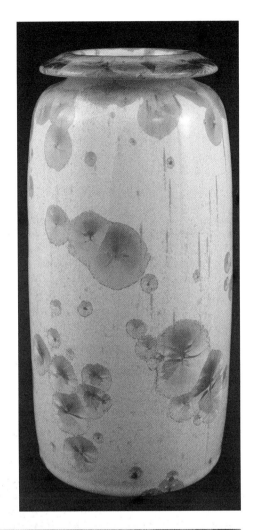

Halos

Startling effects can be achieved by creating growth rings or halos. Rings can be seen in the crystal itself, radiating outward from the centre, like wave lines when a pebble is tossed into a pool. This can be achieved by raising and lowering the temperature several times throughout the soak range. With each rise and fall in temperature, a ring forms around the central core of the crystal and extends outward with subtle colour variations. Placement of rings can also be controlled, depending on when in the firing cycle rises and falls occur. Holding the kiln at a specific temperature for the greater part of the soaking time, then introducing the rises and falls near the end, creates rings on the outer part of the crystals. To produce rings closer to the core of the crystal, raise and drop the temperature at the beginning of the soak time.

Controlling the crystal shape

Different shapes of crystals can be achieved by controlling soak temperature. Once the fusion point of the glaze is established, the crystal-growing band can be predicted.

Crystals shaped like rods or needles are achieved by soaking at the hottest end of the crystal-growing band. A few degrees cooler produces rods which radiate out at their extremities. Next are Maltese cross shapes. Cooler still produces crystals which resemble dandelion puffs or skyrockets exploding, with

Left, above
Vase by Diane Creber, Canada, 12in. h.

Left
Detail showing halos by Mimi Dann, USA.

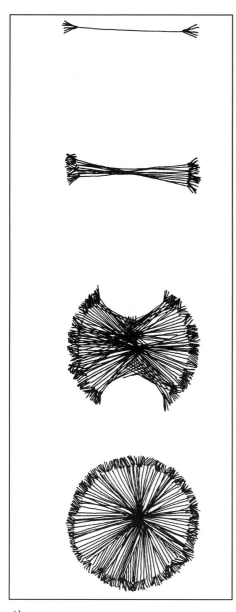

rods radiating from a central core. A further lowering of temperature produces flowerlike crystals with pansy or iris patterns at their centres.

For those who do not have a programmer for exact temperature control, keeping temperature within 100°F (55°C) of the target temperature over a four hour period usually produces a variety of crystals.

A soak time of two hours or less produces small to medium-sized crystals. Three to four hours produces rather large crystals. Five to six hours produces even larger crystals, but the crystals may butt up against or overlap one another. When crowded together, their growth becomes restricted and they do not appear as grand or spectacular. This temperature outline is not specific. It is necessary to experiment with each particular glaze to find its most favourable growth patterns. Once the appropriate fusion temperature is determined, 10°C variations in growth phase can be performed over a series of firings. This will provide an understanding of optimal conditions for crystal formation.

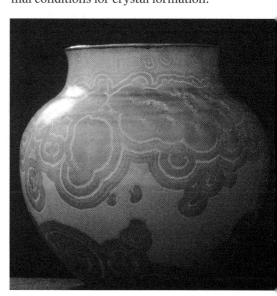

Above
Variations in crystal shapes going from hotter to cooler temperatures within the crystal-growing range.

Right
Vase by Marthe Sirois, Canada, showing halos achieved by raising and lowering the temperature within the crystal-growing range.

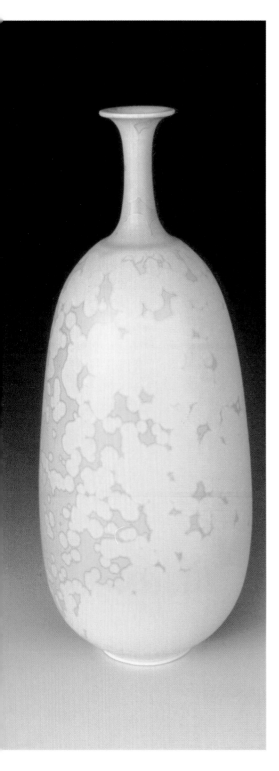

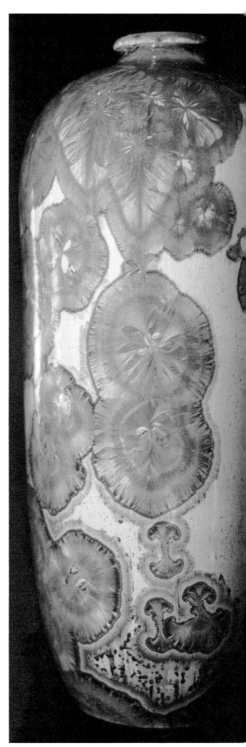

Far left
Bottle by Hein Severijns, The Netherlands, 13in. h. Crystalline matt glazes achieved by a complicated series of holding, dropping and raising of temperature.

Left
Vase with halos in the crystals by Leslie Ehrlich, USA, 6¾in. x 3in.

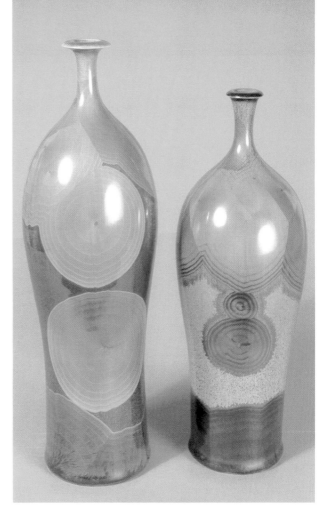

Right
Bottles showing halos by Derek Clarkson, England, 10in. and 9in. h.

Below
Powder box by Joyce Greenhill, USA, 6in. x 4in.

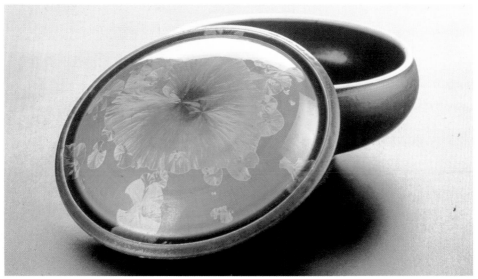

Chapter Eleven
Reduction-fired Crystalline Glazes

In an electric kiln, elements resist current flow. This causes friction and heat. The kiln collects and stores the heat, and no combustion takes place. The atmosphere is clean. Firing a kiln in this atmosphere is called 'firing in oxidation', although the atmosphere is really neutral.

In a fuel kiln, oxygen is essential for combustion. Its supply can be restricted by either shutting the chimney damper down or reducing oxygen supply to the burners. A combination of both is ideal. This creates positive pressure within the kiln, reducing the draw of oxygen to the combustion chamber. Introducing more fuel than can be sufficiently burnt off creates excess smoke (carbon) in the atmosphere of the kiln. Carbon adheres to and is absorbed by the clay and glazes, altering fluxing action and dramatically changing the colours of both. This is

Sphere by Diane Creber, Canada, 6½ in. h

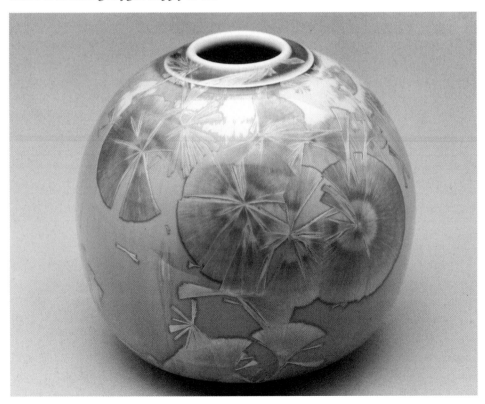

called a 'reduction' atmosphere (reduced oxygen to fuel). Most metallic oxides used as colourants react differently in a reduction atmosphere. For example, copper fired in oxidation is green, in a neutral atmosphere is white, and in reduction goes red. A clay body that has iron in its composition, when fired in a reduction atmosphere, loses its paleness and becomes a toasty colour. Glazes containing iron are enhanced by reduction both in colour and fluxing action.

There are various ways of introducing a reduction atmosphere into an electric kiln (this will be discussed later), but extended reduction in electric kilns leads to constant element breakdown and increased repair costs. Synthesised reduction (the addition of silicon carbide to the glaze) is practical but seldom gives desirable results.

It is generally believed crystalline glazes have to be fired in an oxidising atmosphere in order to get crystals. In his book, *Glazes For Special Effects*,[1] Herbert Sanders states, 'Since a reducing atmosphere inhibits crystal formation, avoid using reducing conditions when firing crystalline glazes' and Taxile Doat, in *Grand Feu Ceramics*,[2] states, 'The presence of zinc oxide in this glaze makes it necessary to have a strictly oxidizing atmosphere'.

That is not to say that crystalline glazes must be fired in an electric kiln. Before widespread access to electric power, crystalline glaze firings were done in fuel kilns. Most crystalline-glazed pots were fired in saggars (clay boxes which protect the ware from direct combustion)

Covered jar by John Tilton, USA.

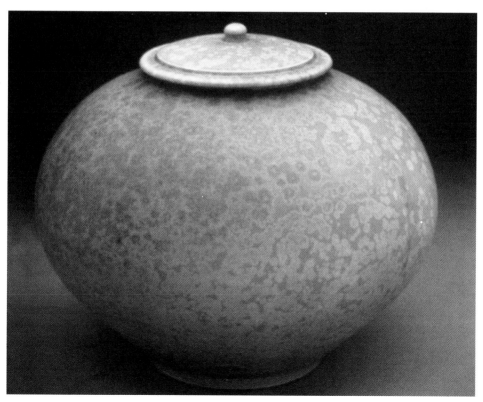

in an oxidising atmosphere. Cones were used to determine the maximum temperature, then the kiln was shut down and the temperature allowed to drop very slowly during the initial cooling period. There would have been no accurate way to measure temperature while the crystals were growing. With the introduction of more accurate temperature measuring devices in the last several years, crystals can now be grown in a fuel-burning kiln in an oxidising atmosphere, and crystal-growing temperatures can be monitored.

Certain colours can be achieved only in a reduction atmosphere. But reduction has an adverse affect on crystal formation. Is it possible to produce these colours and still get crystals? Adelaide Robineau produced some exceptional copper-red crystalline-glazed pots that were fired in a fuel-burning kiln in a reduction atmosphere. The crystals, however, were very small.

Although reduction may inhibit size of crystals, some potters are deliberately firing crystalline glazes in reduction. Results can be very striking and unusual. There are several different procedures. John Tilton (Alachua, Florida) does one-of-a-kind matt crystalline glazes on porcelain, reduction-fired in a gas kiln. Crystals range in size from 2cm (¾ in.) in diameter to the size of the head of a pin. The crystals also vary in opacity, ranging from translucent to opaque. Tilton skilfully creates the illusion that the glaze is emerging from within the piece, rather than being an applied surface. The translucency of the fired porcelain itself contributes to this effect.

Tilton's pieces are fired to cone 10/11 range. The gas kiln is specially designed to cool slowly and radiate heat inward during cooling. Usually he allows the kiln to cool naturally (with no soaking period). Currently, he is beginning to experiment with maintaining a kiln temperature of around 2200°F (1204°C) for one hour. Tilton will fire a piece numerous times, until he is pleased with it. Tilton only fires these glazes in a reduction atmosphere. In oxidation, the glazes appear dull, taking on the look of enamel paint.

With a matt crystalline glaze palette, which includes various shades of almost

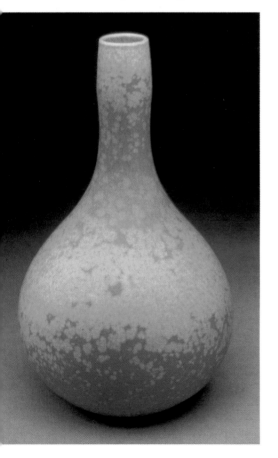

Left
Bottle by John Tilton, USA, 8in. x 4in.

Right
Pitcher by William Sawhill, USA. Crystalline glaze with copper colourant.

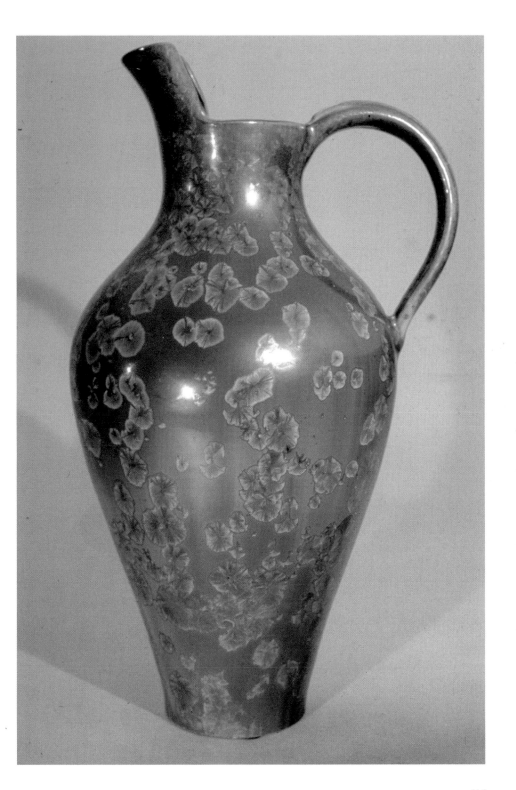

every colour imaginable, the variety Tilton achieves seems endless. Textural effects are rich and diverse. 'I'm interested in surfaces that do not appear to be surfaces because of their depth,' he says.

An insatiable experimenter and glaze developer, Tilton performs hundreds of glaze tests each year, formulating all the glazes he uses on his pieces. Glaze application is complex. A piece may receive several dips into the same or different glazes, followed by a session with his airbrush, which he uses to highlight, fill-in, or complement a pattern being developed on the pot's surface. The glazes are extremely sensitive to thickness, and application is a tedious process. Tilton finds that 0.008 to 0.012 inch glaze thickness works best. This is accomplished in three layers. The first two are dipped and the final is airbrushed. Precise records are kept on each piece to record how certain glaze effects are achieved. With luck, these glazes will not run, so provision for overflow is not usually made.

Tilton has particular success with his 'Celestial Pink' glaze in which variations of colour are achieved with alterations or additions of oxides.

Tilton's Celestial Pink Glaze (Cone 10/11, reduction)

Nepheline syenite	40.47%
Barium carbonate	30.95
Whiting	9.53
Ballclay	7.14
Titanium dioxide	7.14
Tin oxide	4.76
	100.00%[3]

Arne Åse (Oslo, Norway) creates copper-red crystals in an electric kiln with gas reduction capability. The car kiln was built with fibre insulation and Kanthal Super elements. Computer-operated, it

can be adjusted progressively by means of three thyristor units. Reduction is brought about by a built-in gas supply, using roughly ¾ pint of gas per firing. Noiseless and almost non-pollutive, it consumes energy equivalent to 25% of a typical gas-operated kiln.

Åse's crystals are very tiny, but the overall effect is exceptionally striking.

Åse's Copper-Red Crystalline Glaze 2 (Cone 8/9, reduction)

Barium carbonite	9.47%
Colemanite	5.26
Zinc oxide	38.95
Potash feldspar	27.38
Flint	16.84
	100.00%
Add: Copper oxide	5.26%[4]

William Sawhill (Sunnyvale, California) uses crystalline glazes with copper as a colourant. Pots are fired in an electric kiln in a conventional crystal glaze firing. Then he re-fires the pots in a gas kiln to cone 018 (1322°F, 717°C) in a reducing atmosphere. The glaze is still slightly molten at this temperature, so active carbon in the kiln atmosphere affects copper in a manner similar to a lustre glaze. This process results in reds, purples, pinks, bronzes and various combinations of these colours.[5] Another method for achieving reduction effects involves creating a reduction atmosphere within an electric kiln. Julie Brooke (San Diego, California) and Leon Bush (Tarzana, California) use this procedure. It consists of introducing vegetable oil via a porcelain pipe (designed to fire tiles on) through the lowest peephole bung of the kiln. Attached to the pipe is a piece of surgical tubing which comes off the spigot at the base of a pot made to hold the oil. Flow is controlled by means of a pinch valve just below the

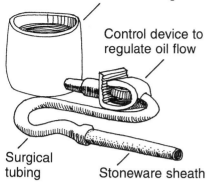

Thrown container for cooking oil

Control device to regulate oil flow

Surgical tubing

Stoneware sheath

Julie Brooke's oil drip method.

spigot. The kiln is fired quickly to maximum temperature (cone 9), then it is shut off and allowed to cool to crystal-growing range. The kiln is turned on again, and temperature is held for three or more hours while the crystals grow. Then the kiln is allowed to cool naturally. Oil is introduced between 1500°F (815°C) and 1000°F (540°C), at which time reduction takes place. The pinch valve is adjusted to allow oil to enter the kiln at approximately one drop per second. The oil ignites immediately creating carbon within the kiln. This procedure should be done only in a well-ventilated atmosphere and with an extraction exhaust system which is capable of expelling all unspent, noxious gases.[6]

I use a similar method but replace the pot of oil and surgical tubing with a hospital I.V. feeding system which can be purchased at any hospital supply store. It consists of a top-loading, 2-litre plastic food bag that I fill with vegetable oil, and has a surgical tube leading off it. Attached to the tube is a flow control which regulates the drip. The bottom end of the tube is inserted into a porcelain sheath, the kind that goes around a pyrometer, or a tube can be made. The

sheath is inserted into the bottom spyhole of the kiln.

Flow of oil is adjusted to about one drop per second. I do the reduction between 1500°F and 1250°F (815°C–675°C). Carbon soot sometimes appears on the pots but can be washed away after cooling. By stopping reduction at 1250°F (675°C), I find most of the soot has burned away.

Sugar cubes inserted through spyholes while temperature is dropping (between 1500°F–1250°F, 815°C–675°C) also creates a reducing atmosphere. As the sugar burns, carbon is produced and reduction takes place. This method produces very spotty reduction and inconsistent results.

During all reduction firings, spyholes and vents should be closed to prevent combustion from taking place. Reduction firings should only be attempted outdoors or in well-ventilated areas with efficient exhaust fans capable of extracting noxious fumes and carbon.

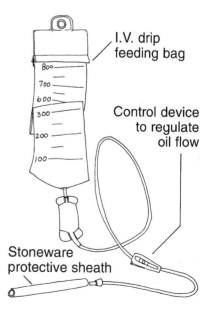

I.V. drip feeding bag

Control device to regulate oil flow

Stoneware protective sheath

Oil drip method using I.V. feeding system.

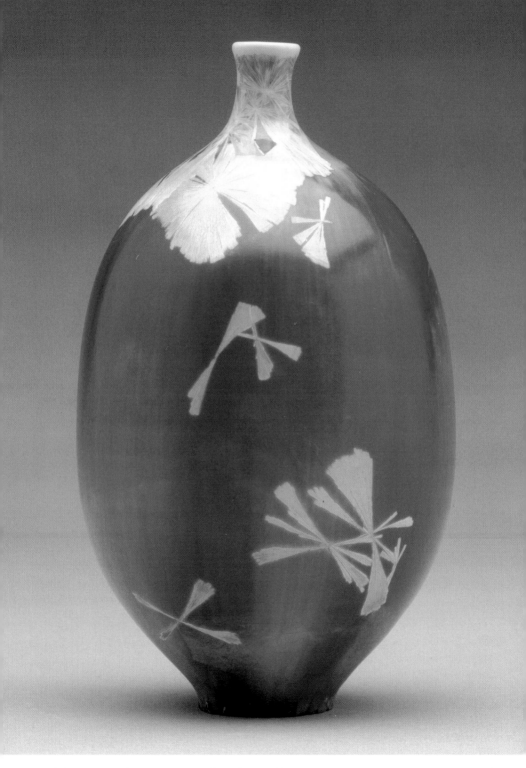

Bottle by Diane Creber, Canada, 6in. h. Reduction fired. Glaze contains copper, manganese and cobalt colourants.

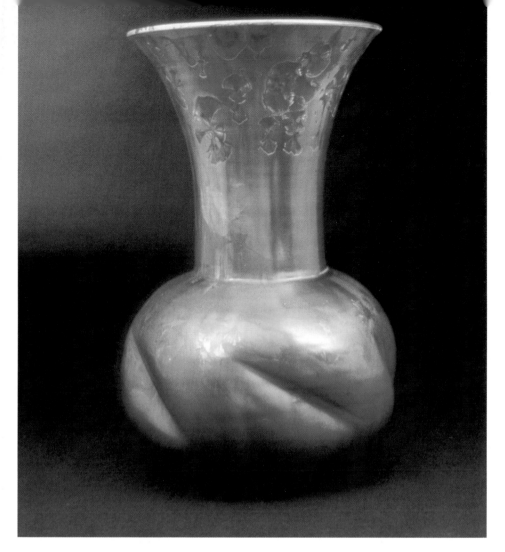

Vase by Julie Brooke, USA, 16in. h. First fired in oxidation for crystals, then in reduction to develop copper red.

Experimenting is necessary to discover how much fuel (be it oil or sugar cubes) is necessary to create desired results. I have found that most crystalline glazes containing copper as a colourant are suitable for reduction firings. Particularly striking results have been obtained with copper in combination with manganese. Reduction firings of crystalline glazes offer even more variety to an already colourful glaze process.

Notes

1 Sanders, Herbert H. *Glazes For Special Effects*, Watson-Guptill Publications, New York, 1974, p. 39.
2 Doat, Taxile. *Grand Feu Ceramics*, Keramic Studio Publishing Company, Syracuse, New York, 1905, p. 181.
3 Tilton, John, and Anne Stewart. Correspondence, with permission, June, 1990.
4 Åse, Arne. 'A View From Norway', *Ceramics Monthly*, May, 1985, pp. 41-43.
5 Sawhill, William. Correspondence, February, 1991.
6 Brooke, Julie. Correspondence, September, 1990.

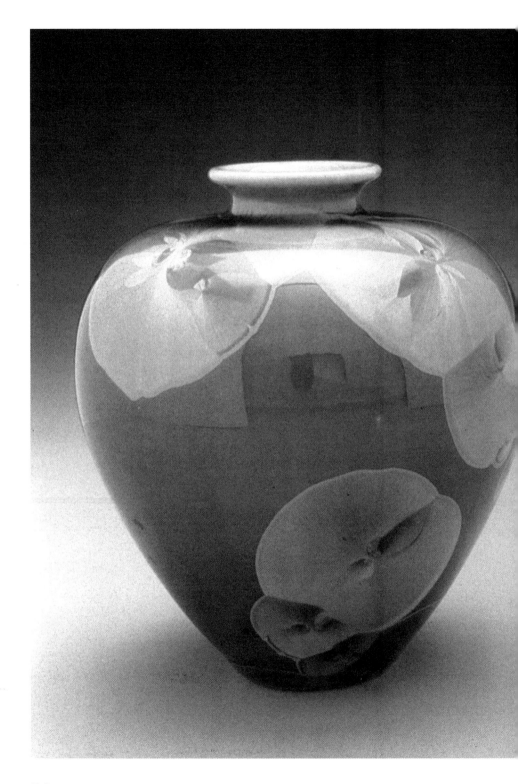

Chapter Twelve
After the Firing

Results of crystalline-glaze firings are often unpredictable. When the kiln is opened, sometimes surprises are in store. We are joyful of our successes and we learn from our mistakes.

The kiln should be allowed to cool naturally. This facilitates a longer life for the kiln and its elements. The temperature should drop to below quartz inversion temperature (410°F, 210°C) before opening the door or spyholes. Wait until pots can be handled without protective gloves before unloading the kiln. Pot, pedestal and collection dish are usually stuck together when a pot is lifted from the kiln. Remove pieces by picking them up by their collection dishes. I have picked up a pot with the collection dish still attached, only to have it separate from the pedestal or base in mid-air, fall into the kiln, and break other pieces.

Removing pots from pedestals

Tools required for removing pots from pedestals include:
- an apron or cloth to protect the lap from broken glass shards,
- safety goggles,
- a diamond-tipped glass cutter,
- a ½ in. (13mm) titanium-tipped chisel or a ½ in. (13mm) drill bit, and
- a small hammer.

Left
Vase by Louise Reding, USA.

A diamond glass cutter is more expensive than a regular glass cutter, but it never becomes dull. The diamond point is capable of cutting deep into the glaze, breaking the bond. Run the glass cutter around the seam line where the bottom of the pot joins the top of the pedestal. Often, the pot will break away at this time. If not, put on the safety goggles and, using the hammer, tap the seam line with the chisel. A few light taps should cause separation.

Sometimes glaze seeps between the joints, causing pieces to remain stuck. Many light taps around the seam should cause it to break free. Be careful about tapping too hard, and don't tap repeatedly in one area. Teardrop forms are inclined to break above the foot rim where the clay is thinner.

If it becomes difficult to remove a pot from its pedestal, here are a few suggestions:

- use a thicker paste of kaolin with the glue,
- make sure the seal between foot rim and pedestal is tight and no glaze can flow into this area,
- re-score the line around the seam and make many small taps, and
- make sure the chisel tip is very sharp.

After pots are removed from pedestals, bottoms must be ground clean and smooth. A silicon carbide grinding wheel should be used for grinding pot bottoms.

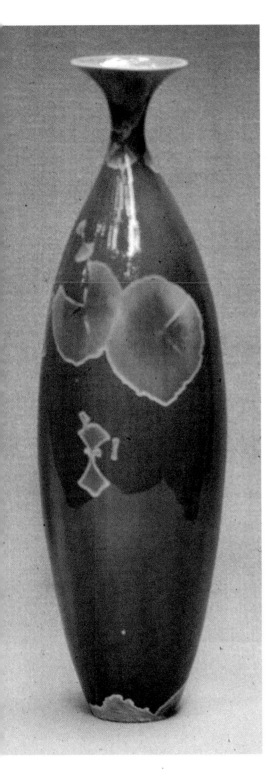

Metal grinding wheels create too much heat at contact points. The ground area then cools quickly and may shatter. If the pot survives a metal grinding wheel, it may be left with a dark, dirty-looking bottom.

Jeweller's grinding stones (14,000 rpm), lapidary grinding wheels, or glass-blowers' equipment designed for levelling bases also work well for removing excess glaze and smoothing bottoms. Ineffective grinding detracts from the overall finished quality of the piece.

Left
Bottle by Herman Weeren, USA, 9in. h.

Below
Covered jar by Mary Ichino, USA. Photo by S. Niedenthal

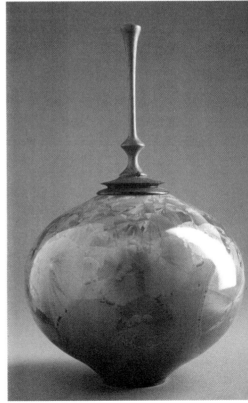

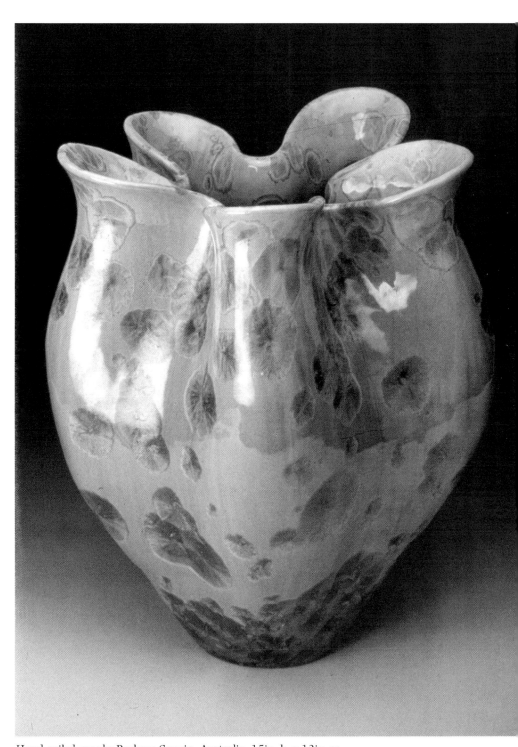

Hand-coiled vase by Barbara Cauvin, Australia, 15in. h. x 13in. w.

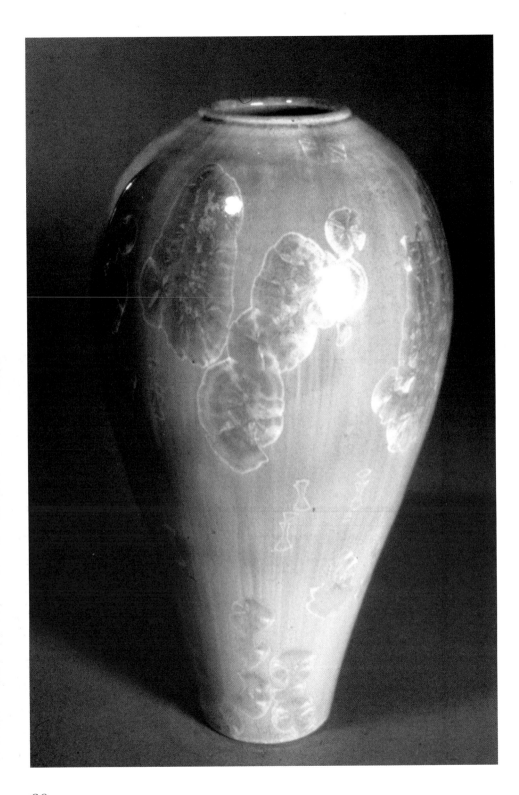

80

Chapter Thirteen
Attitudes and Aesthetics

Crystalline glazes hold the power to fascinate and elicit strong emotions. Watch someone discover a crystalline-glazed pot. They pick it up with great care, turn it to the light, stroke and admire it. Nevertheless, crystalline glazes do have their critics. Because of its ability to attract attention, a crystalline glaze is sometimes thought of as little more than a 'pretty face' or a 'cheap trick'. After the dazzle, what else is there?

In *Clay and Glazes for the Potter*, Daniel Rhodes says, 'The presence of spectacular crystals on the sides of a pot, interesting though such crystals may be in themselves, has, in most cases, contributed as little to the aesthetic significance of the piece as it has to the function'.[1] I agree with Rhodes that a unique glaze, by itself, does not ensure aesthetic significance. Mastering crystalline glazes is only part of the equation. They demand discreet use. Technology must not overpower artistry. Simply because a pot has an unusual or dazzling glaze does not necessarily increase artistic value.

A crystalline glaze on a suitable piece can be quite striking, but the form must be uncluttered and elegant. A simple, aesthetic shape will display the glaze to its best advantage. Aesthetic significance depends upon harmony between glaze and form. A crystalline glaze is not for a bean pot or a coffee mug.

Learning to produce crystalline glazes is no more difficult than working with copper reds, lustres, or salt glazes. But to really know a crystalline glaze and when

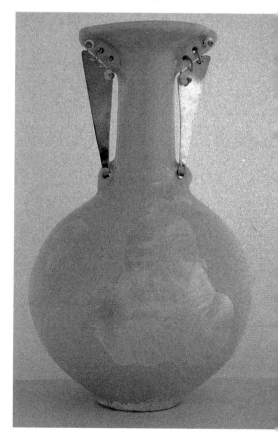

Left
Vase with opalescent crystalline glaze by Joyce Greenhill, USA, 10in. x 5in.

Right
Vase with white crystalline glaze with lustre overglaze by Flora Christeller, New Zealand.

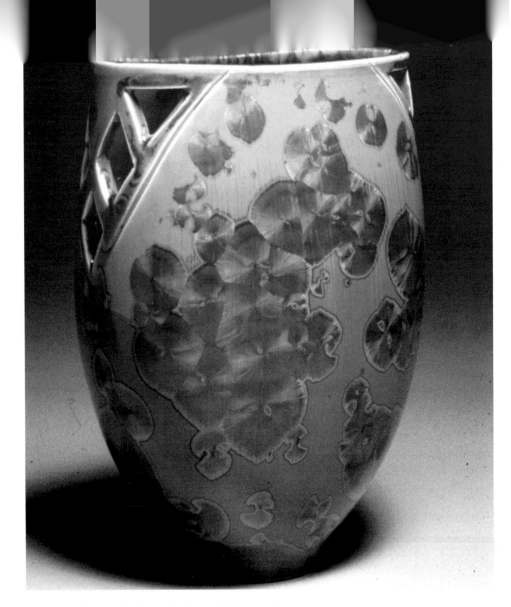

Oval vase with carved sides by Frank Neef, USA.

Note

1 Rhodes, Daniel. *Clay and Glazes for the Potter*, Chilton Book Company, Pennsylvania; A & C Black, London, 1957, p. 189.

to use it is both an acquired skill and an expression of aesthetic sensitivity.

Most potters strive towards making beautiful forms that are in harmony with their glazes. To create glazes which suggest floating galaxies, frosty windows, rare gemstones, or flowers is an exhilarating experience. A beautiful form in combination with a glaze that is mesmerising defines crystalline glazing.

Appendix One
Clay Recipes

Porcelain clay body recipes

The following porcelain clay body recipes are given as parts by weight:

David Leach (England) cone 10

Grolleg china clay	500
Potash feldspar	250
Flint	200
Bentonite	50

David Snair (USA) cone 10

Edgar plastic kaolin	400
Tennessee ballclay (O.M.#4)	89
Flint	177
Nepheline syenite	316
Bentonite	22

David Snair (USA) cone 10

Edgar plastic kaolin	344
Flint	250
Custerspar	250
Ball (O.M.#4)	156
Macaloid	1

HH Porcelain (Pottery Supply Company, Canada) cone 11

Edgar plastic kaolin	450
Flint	350
G.200	250
Bell Ball	150
Ferro bentonite	36
Epsom salts	3

Bevan Norkin (USA) cone 11

Grolleg porcelain	160
Edgar plastic kaolin	150
Tennessee ballclay #10	280
Flint (silco sil 200s mesh)	210
G.200	210
Whiting	40

Susan Bunzl (Germany) cone 11

English china clay	550
Potash feldspar	200
Flint	300
Bentonite	20
Macaloid	10

Casting Clay Body Recipes

From Bevan Norkin (USA) cone 10

Grolleg kaolin	300
Tennessee ball clay #10	150
Flint	200
G.200 feldspar	350

Add K brand deflocculant, 250cc per 200 lb. dry wt. 1 gallon water to 20 lb. dry wt. of clay

From Harlan House (Canada) cone 12

Grolleg kaolin	500
G.200 feldspar	300
Flint 400s mesh	200
Water	400

Add 112g sodium silicate
or 175g Darvan #7.

When making a casting body, the specific gravity should be between 1.77 and 1.80.

Appendix Two
Frits

Listed below are the compositions of frits most commonly used with crystalline glazes. The Bayer J-239-P frit is almost the same as the former Pemco 283, Ferro 3293, O. Hommel K-3, and Gloster GF-106 frits and can be substituted for them.

	Ferro 3110	Ferro 3124	Ferro 3134	Bayer J-239-P	Degussa 90208m
K_2O	2.3	0.7	–	–	–
Na_2O	15.3	6.3	10.3	16.6	29
CaO	6.3	14.1	20.1	0.3	–
MgO	–	–	–	0.7	–
Al_2O_3	3.7	9.9	–	5.9	9.5
B_2O_3	2.6	13.7	23.1	–	–
SiO_2	69.8	55.3	46.5	76.5	62
Fusion Temperature	1400°F 760°C	1600°F 871°C	1450°F 787°C	1420–1670°F 771–910°C	1634°F 890°C

Appendix Three
Glaze Recipes

Macrocrystalline glaze recipes

Macrocrystalline glazes are usually fired to cone 9 or higher. The cone number above each glaze recipe represents the maximum temperature to which the kiln is taken. After this cone is reached, the temperature should be dropped quickly to the crystal growing temperatures and held there for a determined amount of time, or the temperature should be allowed to drop slowly within the crystal-growing range.

The crystal-growing range usually lies somewhere between 2170°F and 1850°F (1187°C–1010°C). Crystal-growing range temperatures can be determined through experimentation. The crystal-growing temperatures for each glaze can be somewhat difficult to predict but usually are within 125°F (52°C). Colourants added to the glaze recipe may alter these temperatures slightly.

Fritted crystalline glazes

For the sake of convenience, most crystalline glazes contain frit. Glazes that contain frit are insoluble in water and can be stored indefinitely.

David Snair, (USA) cone 9-10

	#1	#2	#3	#4
Ferro frit 3110	48.40 parts	47.14	47.86	46.00
Zinc oxide	24.35	28.38	23.87	26.83
EPK	1.52	0.60	1.41	1.35
Flint	17.95	18.02	20.91	20.10
Titanium	7.78	5.86	5.95	5.72
Total	100.00	100.00	100.00	100.00

Add cobalt, manganese or copper or various combinations of two or three of these colourants to total 8%.

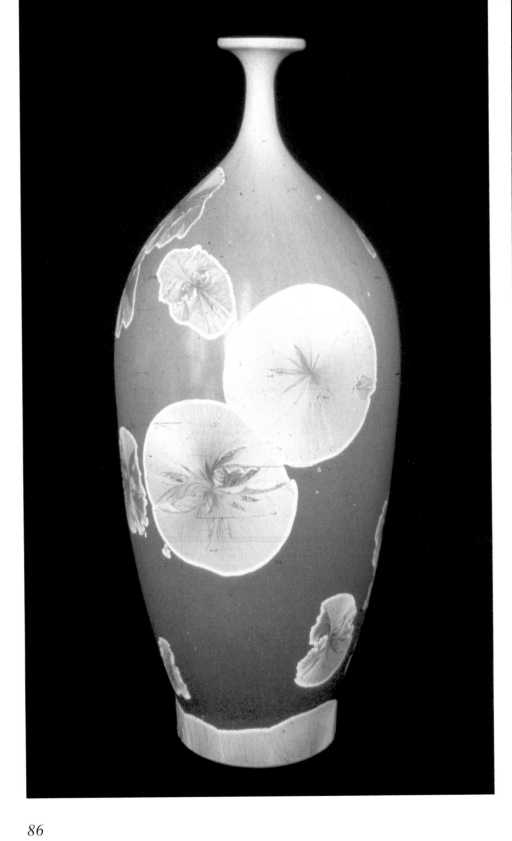

John Conrad (USA) Snowflake Glaze
cone 9

Frit 3110	57.00 parts
Zinc oxide	25.00
Flint	18.00
Total	100.00

Louise Reding (USA) cone 12

Bayer J-239-P	54.55 parts
Zinc oxide	27.27
Flint	18.18
Total	100.00

Addition:
Cobalt 2.30

Louise Reding cone 12

Bayer J-239-P	53.57 parts
Zinc oxide	28.57
Flint	17.86
Total	100.00

Addition:
Manganese dioxide 6.00

Louise Reding cone 12

Bayer J 239-P	58.45 parts
Zinc oxide	25.97
Flint	15.58
Total	100.00

Addition:
Iron oxide 1.56

Rosslyn Reed (Canada) cone 10

Frit 3110	50.89 parts
Zinc oxide	25.66
Flint	18.93
Kaolin	1.58
Titanium dioxide	2.94
Total	100.00

Addition:
Manganese dioxide 3.00-8.00

Left Bottle by David Snair, USA.

Derek Clarkson (England) cone 10

Frit 3110	47.44 parts
Zinc oxide	25.33
Flint	19.55
Titanium dioxide	6.43
China clay	0.75
Alumina hydrate	0.50
Total	100.00

Addition:

Cobalt carbonate	0.25
Manganese dioxide	1.00

Joyce Greenhill (USA) cone 10

Frit 3110	59.00 parts
Zinc oxide	24.60
Flint	15.90
Kaolin	0.50
Total	100.00

Additions:
Prussian Blue

Nickle oxide	0.75
Manganese dioxide	4.00

Mauve

Manganese dioxide	8.00

Mint green

Copper dioxide	3.00
Titanium dioxide	8.00

Ivory

Iron oxide	1.00
Titanium dioxide	8.00

Marthe Sirois (Canada) cone 10

Frit 3110	49.00 parts
Zinc oxide	24.50
Flint	24.50
Bentonite	2.00
Total	100.00

Addition:
Powdered ilmenite 1.00-3.00

Bevan Norkin (USA) cone 11

Frit 3110	46.69 parts
Zinc oxide	32.68
Flint	13.54
Lithium carbonate	.09
Bentonite	1.40
Red iron oxide	2.80
Green nickel oxide	2.80
Total	100.00

Bevan Norkin (USA) cone 11

Frit 3110	40.78 parts
Zinc oxide	28.55
Flint	23.65
Black copper oxide	5.71
Lithium carbonate	0.08
Bentonite	1.23
Total·	100.00

Marc Hansen's Crystalline Glaze
cone 10

Bayer J-239-P	73.20 parts
Zinc oxide	21.00
Flint	4.80
Bentonite	1.00
Total	100.00

Additions:

Manganese carbonate	5
Cobalt carbonate	1
Rutile	1
Copper carbonate	3
Iron oxide	5
Nickel oxide	1
Copper carbonate	3

The following glazes contain unfritted materials and should be used immediately.

Cone 9

Zinc oxide	21.40 parts
Flint	42.20
Sodium carbonate	11.60
Whiting	6.60
EPK kaolin	18.20
Total	100.00

Additions:

Copper carbonate	3.1
Rutile	5.3

Cone 10

Zinc oxide	19.00 parts
Flint	29.50
Potash feldspar	31.50
Gerstley borate	3.00
Ball clay	3.00
Whiting	8.00
Barium carbonate	6.00
Total	100.00

Additions of cobalt carbonate, copper carbonate, manganese dioxide, iron or rutile alone or in various combinations to total 8% work well.

Cone 3–4

Zinc oxide	22.20 parts
Flint	42.80
Soda ash	13.40
Boric acid	15.50
Ball clay	6.10
Total	100.00

Addition:

Rutile	6.70

Reduction crystalline glazes

Any glaze with copper as a colourant may be fired in reduction. The crystals will be very small but a variety of pinks and reds can be achieved.

Arne Åse, Oslo, Norway, cone 8/9 reduction

Barium carbonate	9.47 parts
Colemanite	5.26
Zinc oxide	38.95
Potasium feldspar	27.38
Flint	16.84
Total	100.00

Addition:

Copper oxide

Tilton's Celestial Pink Glaze
cone 10–11 Reduction

Nepheline syenite	40.47 parts
Barium carbonate	30.95
Whiting	9.53
Ballclay	7.14
Titanium dioxide	7.14
Tin oxide	4.76
Total	99.99

Aventurine glazes

The following glazes are soluble in water and should be used immediately.

Aventurine, Glen Nelson (USA)
cone 07–05

Borax	45.70 parts
Barium carbonate	2.60
Boric acid	3.30
Kaolin	1.70
Flint	46.70
Total	100.00

Addition:

Red iron oxide	17.70

G52 Aventurine, from John Conrad
(USA) cone 06–05

Flint	39.70 parts
Borax	38.80
Red iron oxide	15.20
Boric acid	2.70
Barium carbonate	2.20
Kaolin	1.40
Total	100.00

G131 Aventurine, from John Conrad (USA)
cone 04

Borax	57.28 parts
Flint	25.02
Red iron oxide	14.14
Boric acid	3.50
Cobalt carbonate	0.04
Copper carbonate	0.02
Total	100.00

Heavy Iron Aventurine cone 10

Potash feldspar	23.00 parts
Flint	15.50
Colemanite	38.00
Red iron oxide	23.50
Total	100.00

Glossary

ALUMINA (Al_2O_3) A major ingredient found in clays and glazes. In a clay body, it imparts plasticity and strength. In a glaze, alumina assists in the formation of matts and promotes durability and viscosity, making the glaze less likely to run off the vertical form.

ART NOUVEAU A popular style of art, architecture and decoration in the late 19th and early 20th centuries, characterised by the use of curvilinear forms derived from nature.

ART POTTERY Ceramics produced in response to changes in artistic standards that had taken place by the 1870s. A rejection of factory-made pottery and a return to the individual craft-maker.

ATOM The smallest particle an element can be divided into and still retain its identity as that element.

AVENTURINE A type of crystalline glaze usually composed of lead, soda or boric oxide flux. An excess of iron oxide, or some other metallic oxide, is added to the glaze batch. The iron is taken into solution during melting and the iron crystallises out during the cooling cycle, resulting in small crystals forming beneath the glaze surface.

BALL MILL A method of finely grinding ceramic materials. It consists of putting the materials in a jar containing flint pebbles and, as the jar revolves on the mill, the materials are ground.

BATCH Raw chemicals comprising a ceramic glaze that have been weighed out in a specific proportion designed to melt at a predetermined temperature.

BENTONITE A very fine particle-sized clay that is extremely plastic. Small amounts added to a clay body make the clay more plastic. When added to a glaze, it aids glaze suspension.

BISQUE The preliminary firing to strengthen the clay so it may be glazed, but still leaves the clay porous in order to absorb the glaze. The bisque-firing temperature for porcelain is usually between cones 08–04.

CALCINE To heat a ceramic material to the temperature necessary to drive off the chemical water, carbon dioxide, and other volatile gases.

CHEMICAL WATER The water that is chemically combined in clay and glaze compounds. When heated to above 842°F (450°C), the water leaves as vapour.

COLOURANT A mineral or compound of minerals added to a clay body or a base glaze to give colour. Some of the more common colourants are iron, copper, cobalt, manganese and rutile.

CRAWLING The glaze separates during melting and leaves bare spots of clay exposed. Too heavy a glaze application or some of the materials in the glaze having considerable shrinkage are some causes of this problem. Calcining the plastic materials in a glaze recipe helps considerably.

DEVITRIFICATION To change from a vitreous to a crystalline condition.

EARTHENWARE Low-fired pottery (under 2000°F/1095°C). The clay remains slightly porous and is usually red or buff in colour.

EMPIRICAL FORMULA A glaze formula expressed in molecular proportions.

FLUX A substance which causes or promotes melting.

FRIT Manufactured compounds that have been fired to a molten state, cooled, ground to a powder and then used in a glaze to replace materials that may be toxic or soluble.

FUSION POINT The point during a firing cycle when the dry glaze begins to melt and become molten.

GLAZE Minerals that will melt together to form a glassy surface coating when applied to a pot and heated to sufficient temperature.

GROG Clay which has been fired and then pulverised. Grog is added to a clay body to reduce shrinkage.

GUM ARABIC OR GUM TRAGACANTH A gum obtained from vegetation that is used as a binder to help the glaze adhere to the body. The gum swells up and thickens a liquid solution.

ILMENITE An ore containing titanium and iron.

KAOLIN Pure clay. It is an important ingredient for porcelain bodies, is white in colour and can be fired to extremely high temperatures. It also provides a source for alumina and flint in glaze recipes.

MAGMA Glazes in a molten state.

MATT GLAZE The complete surface of the glaze is covered with microscopic crystals. The glaze has a pleasant silky feel and a dull satin appearance.

MATURE The point at which a clay body becomes non-porous, hard and durable, or the point at which glaze ingredients enter into complete fusion.

MOLECULE The smallest particle of an element or compound that can exist separately without losing the physical or chemical properties of the original.

NEUTRAL ATMOSPHERE The atmosphere in a kiln between reducing and oxidising.

OXIDE Any element combined with oxygen.

OXIDATION The atmosphere in a kiln where there is more oxygen present than is necessary for complete combustion.

OPACIFIER A material which remains in suspension in a glaze, causing the glaze to become opaque.

PLASTICITY The ability of clay to be manipulated yet still hold its shape.

PYROMETER A mechanical device for measuring heat at high temperatures.

REDUCTION Firing with reduced oxygen in the kiln. The carbon monoxide thus formed combines with oxygen from the clay body and the glaze to

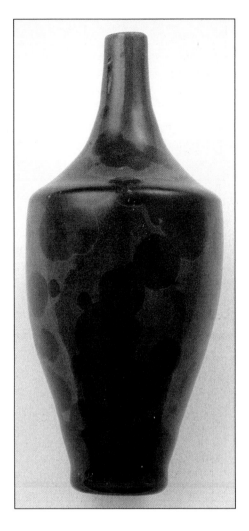

Bottle by Flora Christeller, New Zealand.

certain colouring oxides altering their appearance.

SAGGAR A box made from refractory clay in which pottery is placed to protect it from direct flame or kiln gases.

SATURATION The point at which no more material can be dissolved.

SEEDS, SEEDING AGENTS Ingredients that provide a nucleus in a crystalline glaze around which crystals will grow.

SOAK To hold the kiln at one temperature for a specific length of time.

SILICA Also known as flint or quartz. Silica promotes plasticity in clay bodies, and durability and a glassy melt in glaze recipes.

SOLUBLE Capable of being dissolved in water.

SUSPENSION A uniform dispersion of small, undissolved particles mixed in a medium.

VISCOSITY The non-running quality of a glaze.

VITRIFY To fire to the point of glassification.

WILLEMITE (Zn_2SiO_4) A naturally forming mineral consisting of zinc silicate.

92

Bibliography

Books

Berry, L. G. and Brian Mason. *Mineralogy: Concepts Descriptions Determinations*, W. H. Freeman and Company, San Francisco and London, 1959.

Bodelsen, Merete. *The Royal Copenhagen Porcelain Manufactory 1775–1975*, Copenhagen, 1975.

Cameron, Elizabeth. *Encyclopedia of Pottery and Porcelain 1800-1960*, Facts on File Publications with Cameron Books, New York and London, 1986.

Charleston, Robert J. (ed.). *World Ceramics*, Hamlyn, London, 1968.

Cone Art Kilns Inc. *The Owner's Operating Manual*, Markham, Ontario.

Conrad, John W. *Ceramic Formulas: The Complete Compendium*, Macmillan, New York, 1973.

Cooper, Emmanuel and Derek Royle. *Glazes for the Studio Potter*, Batsford, London, 1979.

Cooper, Emmanuel. *Potters Book of Glaze Recipes*, Batsford, London, 1987.

Desautels, Paul E. *Rocks and Minerals*, Putnam, New York, 1982.

Doat, Taxile. (Translated by Samuel E. Robineau.) *Le Grand Feu Ceramics*, Keramic Studio Publishing Co., Syracuse, N.Y., 1905.

Evans, Paul. *Art Pottery of the United States: An Encyclopedia of Producers and Their Marks*, Charles Schribner's Sons, New York, 1974.

Fäy-Hallé, Antoinette (translated by Barbara Mundt). *European Porcelain of the 19th Century*, Rizzoli International Publications Inc., New York, 1983.

Fraser, Harry. *The Electric Kiln. A User's Manual*, A & C Black, London, 1994.

Gait, Robert I. *Exploring Minerals and Crystals*, McGraw-Hill Ryerson, Toronto, 1972.

Green, David. *Understanding Pottery Glazes*, Faber and Faber, London, 1963.

Gregory, Ian. *Kiln Building*, A & C Black, London, 1995.

Hamer, Frank and Janet. *The Potter's Dictionary of Materials and Techniques 4th ed.* A & C Black, London, University of Pennsylvania Press and Craftsman House, 1997.

Holden, Alan and Phylis Morrison. *Crystals and Crystal Growing*, Anchor Books, Columbus, Ohio, 1960.

Hopper, Robin. *The Ceramic Spectrum*, Chilton, Phildelphia, 1988.

Keramikmuseum Westerwald. *Kristallglasuren*, Kreisverwaltung des Westerwaldkreises, Montabaur, 1987.

Lane, Peter. *Contemporary Porcelain*, A & C Black Publishers, London, 1994.

Leach, Bernard. *A Potter's Book*, Faber and Faber, London, 1945.

Levin, Elaine. *The History of American Ceramics, 1607 to the Present: From Pipkins and Bean Pots to Contemporary Forms*, Harry N. Abrams Inc., New York, 1988.

Nelson, Glenn C. *Ceramics*, Holt, Rinehart & Winston, New York, 1966.

Norton, F. H. *Ceramics for the Artist Potter*, Addison Wesley, Cambridge, 1956.

Perry, Barbara (Ed.). *American Ceramics: The Collection of Everson Museum of Art*, Rizzoli, New York, 1989.

Rhodes, Daniel. *Clay and Glazes for the Potter*, Chilton, Philadelphia; A & C Black, London, 1957.

Rhodes, Daniel. *Stoneware and Porcelain*, Chilton, Philadelphia, 1960.

Rhodes, Daniel. *Kilns Design, Construction and Operation*, Chilton, Philadelphia, 1968.

Sanders, Herbert. *Glazes For Special Effects*, Watson-Guptill, New York, 1974.

Shirley, O. A. (ed.). *Crystalline Glaze: Reading File*, Arkansas, Vol 1, Vol 2 and Vol 3. (Unpublished).

Silbey, Uma. *The Complete Crystal Guidebook*, U-Read Publications, San Francisco, 1986.

Weiss, Peg (ed.). *Adelaide Alsop Robineau: Glory in Porcelain*, Syracuse University Press, Syracuse, New York, 1981.

Zakin, Richard. *Electric Kiln Ceramics 2nd ed.*, Chilton, Phildelphia; A & C Black, London, 1994.

Periodicals

Carroll, Thomas. 'Crystal Glazes in Reduction!' *Ceramic Monthly*, Columbus, Ohio, Vol. 39–3, pp. 35–7, 1991.

Clarkson, Derek. 'The Crystal Maze', *Ceramic Review*, London, No. 137, pp. 27–31, 1992.

Dann, Mimi. 'Crystalline Glazes', *Ceramic Review*, London, No. 128, pp. 36–9, 1991.

Koerner, J. 'New Crystalline Glazes,' *Transactions of the American Ceramic Society*, No. 10, pp. 61–4, 1908.

Kraner, Hobart M. 'Colors in a Zinc Silicate Glaze', *Transactions of the American Ceramic Society*, No. 7, pp. 868–76, 1924.

Machtey, Michael. 'Crystalline Glazes', *Ceramic Review*, London, No. 49, pp. 108–11, 1978.

Norton, F. H. 'The Control of Crystalline Glazes', *Transactions of the American Ceramic Society*, No. 20, Vol. 7, pp. 217–24, 1937.

Pukall, W. 'My Experiences With Crystalline Glazes', *Transactions of the American Ceramic Society*, No. 10, pp. 183–215, 1908.

Purdy, Ross C. and Junius F. Krehbiel. 'Crystalline Glazes,' *Transactions of the American Ceramic Society*, No. 9, pp. 319–407, 1907.

Rand, C. C. and H. G. Schurecht. 'A Type of Crystalline Glaze at Cone 3', *Transactions of the American Ceramic Society*, No. 16, pp. 342–6, 1914.

Riddle, Frank Harwood. 'A Few Facts Concerning The So-Called Zinc Silicate Crystals', *Transactions of the American Ceramic Society*, No. 8, pp. 336–52, 1906.

Schmitz, Robert. 'Crystalline Glazes,' *Ceramic Review*, London, No. 88, pp. 10–11, 1984.

Snair, David. 'Making and Firing Crystalline Glazes', *Ceramics Monthly*, Columbus, Ohio, Vol. 23–10, pp. 21–6, 1975.

Stull, R. T. 'Notes on the Production of Crystalline Glazes', *Transactions of the American Ceramic Society*, No. 6, pp. 166–97, 1904.

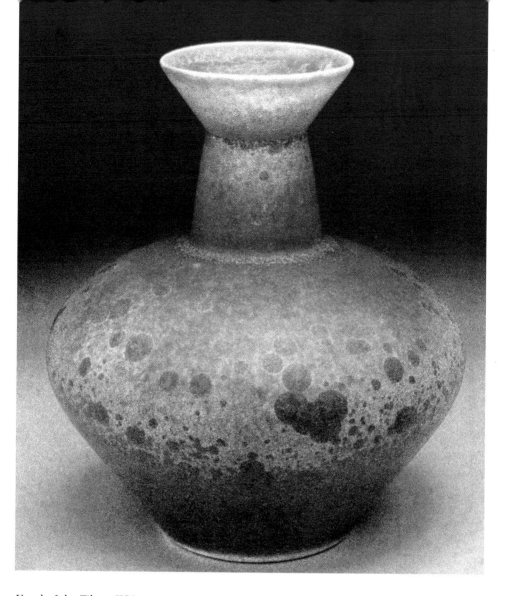

Vase by John Tilton, USA.

Thiemecke, H. 'Notes on Cone 10 Raw Crystal Glazes', *Transactions of the American Ceramic Society*, No. 17, pp. 359–62, 1934.

Vivas, Antonio. 'Cristalizaciones Sobre Porcelana', *Ceramica*, Madrid, Spain, Vol. 1–1, pp. 7–13, 1978.

Vivas, Antonio. 'Cristalizaciones', *Ceramica*, Madrid, Spain, Vol. 2–8, pp. 12–25, 1981.

Worcester, Wolsey G. 'The Function of Alumina in a Crystalline Glaze', *Transactions of the American Ceramic Society*, No. 10, pp. 450–83, 1908.

Index